THE ULTIMATE GUIDE TO

MODERN

Calligraphy

& HAND

Lettering

FOR BEGINNERS

Shop our other books at
www.junelucy.com

Wholesale distribution through Ingram Content Group
www.ingramcontent.com/publishers/distribution/wholesale

For questions and customer service, email us at
support@junelucy.com

want free goodies?

Before we get started- head over to www.junelucy.com/lettering and sign up for my newsletter. By joining, you will receive copies of practice pages from the book (strokes, alphabets, words, connectors and additional projects!), as well as more lettering goodies, tips and tricks, and freebies along the way!

Follow me @Juneandlucy so I can see your progress!

www.junelucy.com/lettering

@JuneandLucy

www.facebook.com/juneandlucy

About ME

Hello there crafty friends of mine! I'm Kristin - mama to the most incredible little human around, graphic designer, hand letterer, and creator of June & Lucy. I love the 4 C's in my life: cats, coffee, couches, and cooking, and as you can tell from my Instagram captions, I think I am much funnier than I probably am.

June & Lucy started in 2016 when my husband and I found out our son was going to be born with a rare form of dwarfism. The constant worrier in me fretted about the additional medical expenses we might be facing, so I started designing and selling nursery artwork in my spare time. After Asher was born, he served as a constant source of inspiration for me - and my art has grown with him, from nursery designs to coloring books and children's activity books, and beyond. But the central skill behind every product I branch out into is my lettering.

I shied away from learning how to hand letter and do any sort of calligraphy for quite a while - in large part because I am, in fact, a lefty. And I will say, once I decided to give it a go - it was quite a learning experience for me, since it didn't come naturally to me right off the bat. I scoured the internet for every lettering video I could find and spent years refining my technique and creating my own lettering style.

My goal with this book is to help you avoid the countless months of research, trial and error, and mistakes that I made along the way, by giving you a straight forward, easy to understand explanation of the process behind hand lettering so that you can start your lettering journey with a strong foundation.

While June & Lucy may only be a few years old, the art behind it reaches back to my earliest of days - back to the 8-year-old little girl who used to ask her grandma to take her birthday shopping at art supplies stores. And that 8-year-old little girl is just plain giddy at the idea of you reading this book of hers.

Don't forget to share your progress with me as you go along on Instagram @JuneandLucy, asking me any questions you have along the way! I can't wait to see what you beautiful people create!

xoxo Kristin

TABLE OF CONTENTS

[are you ready to letter?]

POSTURE & POSITIONING

Let me start by saying that posture, pen grip, and paper positioning are something that I struggled with a lot when starting out, in large part because *gasp* - I am a left-handed letterer. However, whether you are right-handed or left-handed, please have no fear, it can be done!

Let's start out with the basics of how to position your body and hold your pen:

While this one may seem silly to focus on first, since you have in fact moved past elementary school, I'm still going to mention it- and I promise, you will thank me later. When you are lettering, the movement of your pen is incredibly important. And to control that movement properly, you must have your body positioned in a way that you can see everything you are doing, but also have full range of motion. The best way to do this is to be sitting at a table or a desk, both feet flat on the ground, and straight-ish spine. I say straight-ish, because you don't need to be stiff and robot-like, but you also don't want to be hunched over your paper. I keep the forearm of my hand I am lettering with lightly resting on the table, and I use the other hand to help stabilize the paper. With lettering, you will move your entire arm to make the fluid strokes, as opposed to only your hand and wrist. This provides you a greater range of motion and control over the stroke itself.

When holding your pen (or whatever lettering tool you are using), you want a moderate grip on the pen- firm enough that you have steady control, but loose enough so that the strokes flow naturally and easily. Make sure your grip isn't too far away from the tip of the pen or you will not have great control. And last, but certainly not least, when holding a brush pen, it is all about the angle. A brush pen is essentially a marker that has a flexible tip, and if you try writing with the pen tip straight down, you aren't getting the benefit of that flexible tip. By holding the pen at an angle, you are able to make the thin upstrokes and thick downstrokes, depending on the pressure you apply.

As you work on the practice strokes that you will find later in the book, you will start to get a feel for what I am describing. I strongly recommend you keep doing practice drills until you find a grip, body position, and paper placement that make the strokes feel natural and not forced. Be patient though- this is a new type of muscle memory you are trying to learn, and it will take some time.

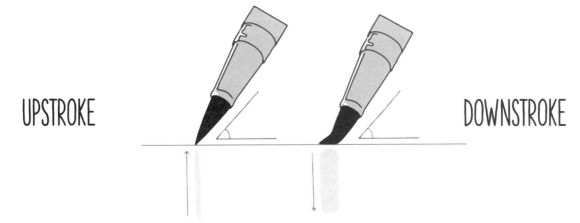

UPSTROKE DOWNSTROKE

The best way to approach hand lettering is to stop thinking about lettering as writing words, and to start thinking about it as drawing words. And just as it is important to understand the anatomy of a body when you are drawing a person, it is equally as important to understand the anatomy of letters when you are lettering.

Here are the basic terms that you will want to familiarize yourself with before you go any further, so that as you draw each letter and word, you know how each of these elements come together to create your final design. I will make reference to these terms as we go along to help guide you as you learn first to duplicate my lettering, and then to create a beautiful lettering style of your very own.

baseline — THE BASELINE IS THE LINE WHERE THE LETTERS REST.

midline — THE MIDLINE (ALSO KNOWN AS THE MEANLINE) IS THE LINE INBETWEEN THE BASELINE AND THE CAP LINE.

ascender — THE ASCENDER IS THE UPWARD VERTICAL STROKE IN LETTERS SUCH AS H, B AND K.

descender — THE DESCENDER IS THE PART OF LOWERCASE LETTERS SUCH AS G, J, Q, P AND Y THAT EXTENDS BELOW THE BASELINE.

serif — THE SERIF IS THE SMALL EXTRA STROKE FOUND AT THE END OF THE MAIN STROKES OF THE LETTER (THE LITTLE FEET).

san serif — SANS SERIF MEANS A LETTER SANS (WITHOUT) THE EXTRA STROKE (FOOTLESS!).

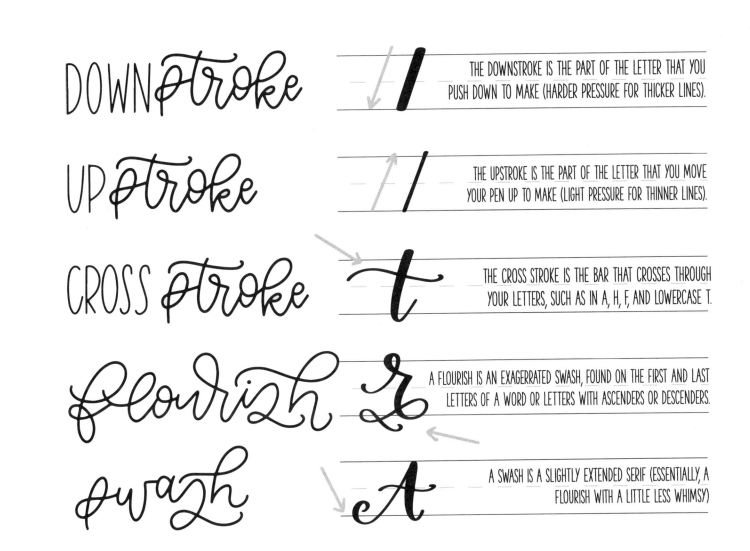

DOWN*stroke* — THE DOWNSTROKE IS THE PART OF THE LETTER THAT YOU PUSH DOWN TO MAKE (HARDER PRESSURE FOR THICKER LINES).

UP*stroke* — THE UPSTROKE IS THE PART OF THE LETTER THAT YOU MOVE YOUR PEN UP TO MAKE (LIGHT PRESSURE FOR THINNER LINES).

CROSS *stroke* — THE CROSS STROKE IS THE BAR THAT CROSSES THROUGH YOUR LETTERS, SUCH AS IN A, H, F, AND LOWERCASE T.

flourish — A FLOURISH IS AN EXAGERRATED SWASH, FOUND ON THE FIRST AND LAST LETTERS OF A WORD OR LETTERS WITH ASCENDERS OR DESCENDERS.

swash — A SWASH IS A SLIGHTLY EXTENDED SERIF (ESSENTIALLY, A FLOURISH WITH A LITTLE LESS WHIMSY)

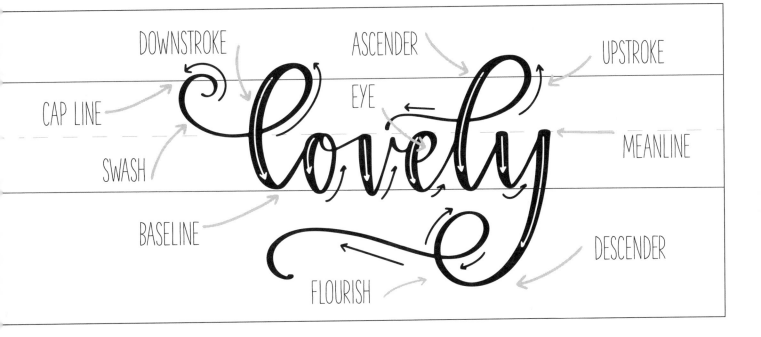

DOWNSTROKE ASCENDER UPSTROKE

CAP LINE EYE

SWASH MEANLINE

BASELINE DESCENDER

FLOURISH

TOOLS AND TECHNIQUES

One of my favorite things about lettering is the limitless options you have with regard to styles, tools and techniques. You can use the same tool (pen, brush, marker, etc.) and letter a word in an unlimited number of styles. You can also letter the same word in the same style using an array of different tools and come up with a wide variety of different effects. In this book, I will cover the two basic styles, Monoline and Brush lettering, and show you how to and add stylistic variations, enhancements, illustrations and more to create those Pinterest and Instagram worthy pieces that we all love so much.

For reference, here are what I consider the three basic styles:

1 *monoline* [TOOL: ROUND, HARD TIPPED MARKER OR PEN]

For monoline lettering, the line width is consistent through the entire letter. You can have a thick line, or you can have a thin line, but you can't have both! Monoline lettering is easier to start with since you use consistent pressure throughout the entire word (no need to worry about changing your pressure between up strokes and down strokes).

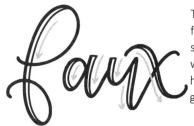

Turn monoline lettering into faux calligraphy by adding a second downstroke to your word after you finish it- like I have done here. Then fill in the gaps (or leave them as is!)

2 *brush*

[TOOL: BRUSH PEN]

For brush lettering (aka Modern Calligraphy), you use a brush pen (or a paintbrush or a marker with a flexible tip) and you apply hard pressure with your downstrokes and light pressure with your upstrokes. It can be tricky to get the hang of, but if you practice enough to master the skill, you can create some of the most stunning pieces of art! Use high quality, or heavy weight paper when using your brush pen, since you need the movement to be very smooth without the brush snagging on the paper fibers.

Use a water brush (or a rounded watercolor brush) to do your brush lettering with watercolors! This is a bit more difficult to master, so I recommend starting with a small brush tip that is easier to control.

3 *traditional* [TOOL: TRADITIONAL POINTED PEN WITH NIB]

With traditional calligraphy, you use a pointed pen (often a wooden or plastic handle with a metal nib attached) and an ink well. You can also use traditional calligraphy "pens", which are the pens with the hard tip with a slanted point. Traditional calligraphy is very structured, and follows pretty standard rules with regard to letter height, spacing, placement, etc. Because it can be very difficult to learn, and therefore frustrating for someone who is just starting out, we won't go over it in this book, and will instead opt for the whimsical monoline and brush styles (fewer rules, more fun!).

Tools of the Trade

ALL. THE. ART. SUPPLIES.

Now, while this is my favorite part of lettering - it can also be intimidating and overwhelming when you are first starting out, and let's be honest - it can seem like lettering is an extremely expensive hobby! So here is a quick run down of the various supplies and tools you can use when lettering. And please, please keep in mind that at the end of the day - a good old pencil and piece of paper can still create some incredibly stunning lettering pieces.

- **PENCILS.** The biggest tool in your arsenal is your pencil. I start every piece by sketching the design out with my pencil before I ever grab a pen or marker. Any pencil will work - from your trusty wooden #2 pencil, to your .7 lead mechanical.

- **PENS.** Pens are great for monoline lettering - especially those that are notoriously smooth, such as the Micron pens. You can also experiment with pens like gel pens or felt tip pens to create a different look.

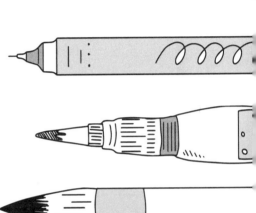

- **MARKERS.** Markers are so versatile when it comes to lettering - and depending on the marker you can achieve a completely different style. Round, hard tipped markers are great for monoline lettering, and many of the major marker brands have even come out with their own version of a brush pen, such as Sharpie and Prismacolor. But some of my favorite practice pieces have come from run of the mill Crayolas!

- **BRUSH PENS.** Ahh, brush pens. My one true love. I love a good brush pen, and there are so many amazing ones out there to choose from, and I encourage you to play around with them to find one that suits you. Because the brush style requires a lot of practice to master, I recommend if you are starting out, start with a smaller and firmer brush pen (such as the Fudenosuke), which are much easier to control when you are still learning.

- **WATERCOLORS.** Watercolor lettering pieces are some of my absolute favorite pieces - and this style can be an absolute blast to play around with. You can use a small watercolor brush, or a water brush pen that you fill up with water. I do recommend getting comfortable with the former supplies before moving onto watercolors since they can be challenging at first.

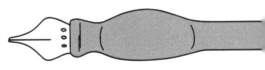

- **CHALK.** Chalk is a great tool to letter with - especially Chalk Pens, which can be used on a variety of surfaces.

- **POINTED PEN.** Pointed pens are what you might think of as traditional calligraphy pens. These typically consist of a barrel and a metal nib, and you use them with an ink well. These are difficult to master, so I recommend starting with one of our other tools.

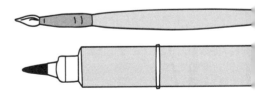

- **PAPER.** Last but certainly not least, paper. And not all paper is created equal when it comes to lettering. You need a high quality paper that will allow for smooth, fluid strokes. Cheap, thin paper will cause not only frustration - but can actually damage your brush pens (causing the annoying feathering to the tips). This book is great for practicing with pencils, pens or markers - but I recommend saving your good brush pens for a higher quality paper. If you want to practice on printer paper, go with a premium laser jet paper!

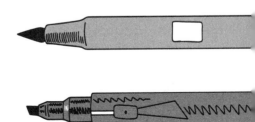

BASIC STROKES

Time to put the pen to the paper! While these strokes show the thick/thin variation for brush lettering, the practice is equally as valuable if you are using a pen/pencil for monoline lettering. The key is to become comfortable making the strokes - up, down, diagonal, waves, loops, etc. These elements, when combined, will form your letters and words and ultimately, your finished piece. If you are doing monoline lettering, and therefore using consistent pressure, then focus on consistency with your strokes. If you are using a brush pen, then remember to apply harder pressure when making down strokes for the thick lines and use lighter pressure when making your upward strokes for the thin lines.

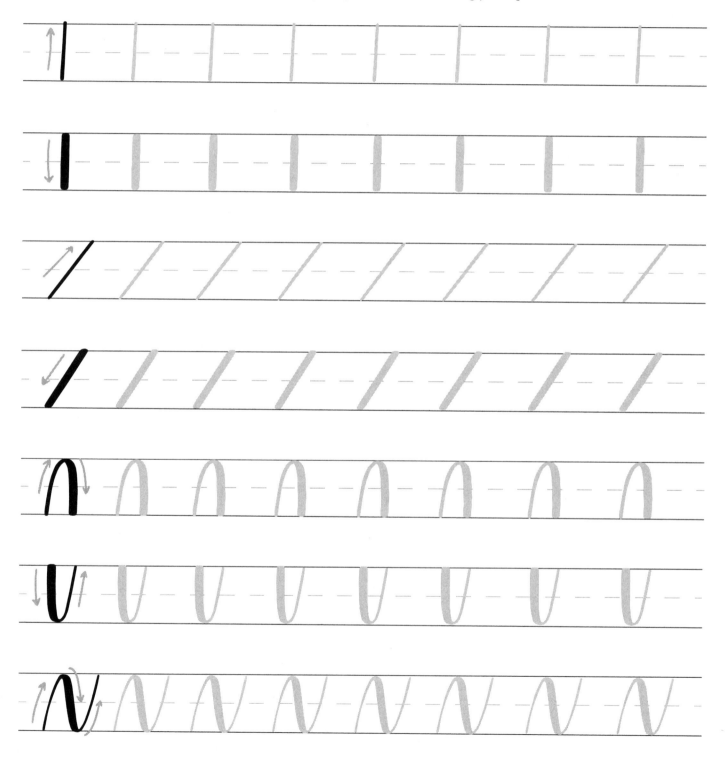

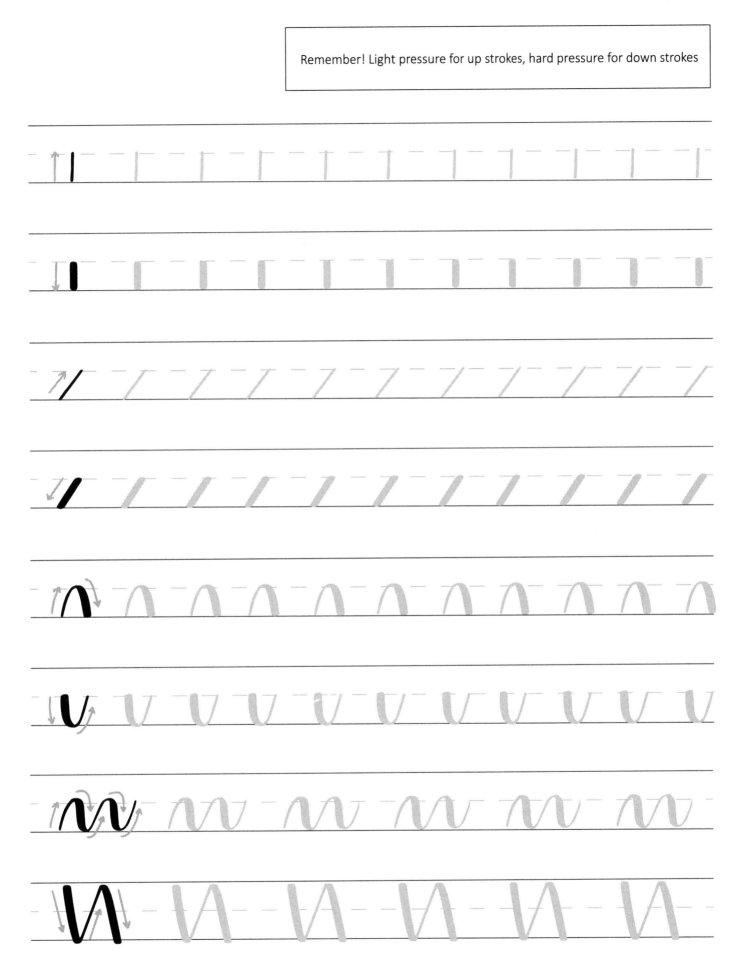

BASIC STROKES

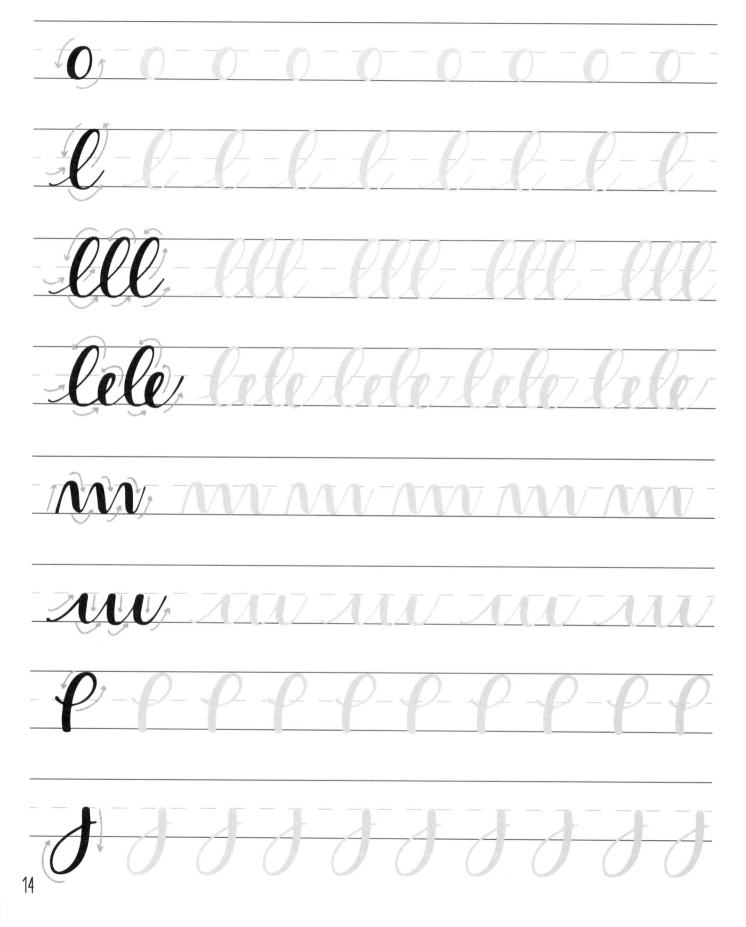

PRACTICE MAKES PROGRESS!

Do not expect perfect strokes at this point but do expect to see progress. I have been lettering for years and still do drills every week to help maintain muscle memory and keep my letters smooth and fluid. So, once you finish these practice drills, print off my free printable downloads you can get by signing up at www.junelucy.com/lettering, and keep practicing!

♡ letters

One of the biggest "ah ha!" moments I remember having when I first started lettering was when I learned that unlike with handwriting (even cursive), with lettering you have to go slow, and pick up your pen after each STROKE. Not after each letter, but each stroke. Lettering is really about drawing the letters, not merely writing them out. Remember all of those strokes you just practiced over and over? Here is where they come into play. Take a look at each letter below and try to visualize each letter as a combination of those various strokes. Your habits from cursive writing may start to take over and you realize you wrote all of the letters, or even a whole word without ever stopping. And that is ok! Old habits are hard to break. But with practice, it will become second nature to you, and you will be well on your way to mastering the art of lettering.

Here, I have broken down the lowercase letter "A" for you to see the individual strokes and how when they come together, they form the letter.

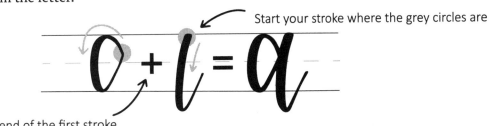

Start your stroke where the grey circles are

Pick up your pen at the end of the first stroke

BASIC BRUSH ALPHABET : LOWERCASE

a b c d e f g

h i j k l m

n o p q r s

t u v w x

y z

BASIC BRUSH ALPHABET / LOWERCASE

Use the guides to practice your letters by tracing my letters first, and then use the blank space to practice drawing them on your own.

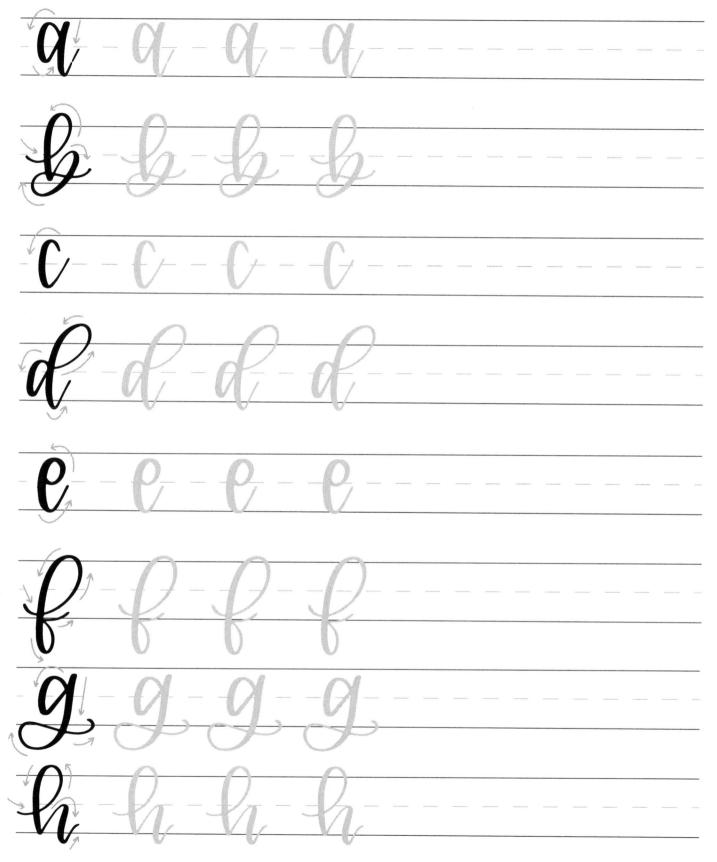

BASIC BRUSH ALPHABET / LOWERCASE

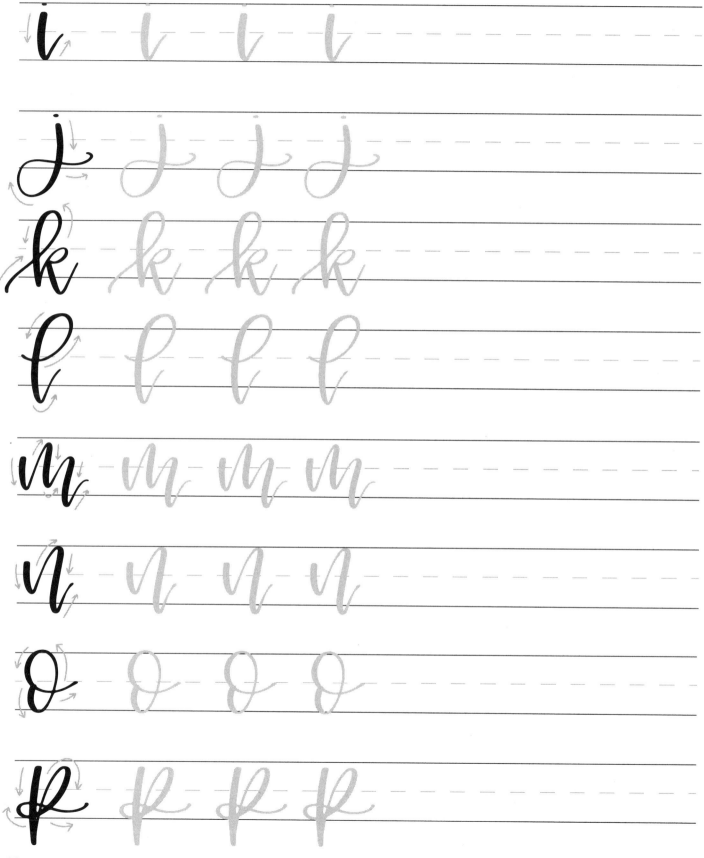

BASIC BRUSH ALPHABET / LOWERCASE

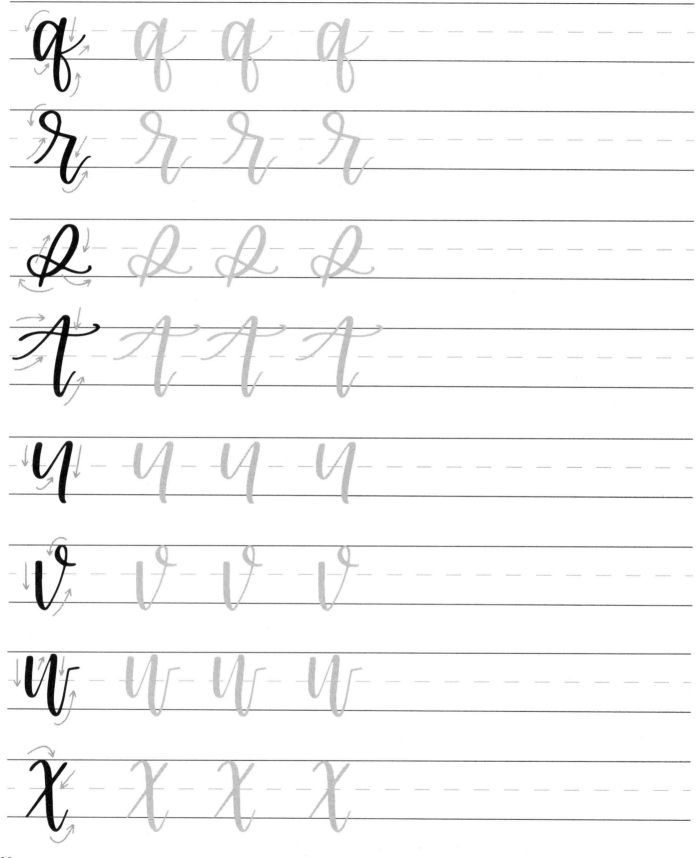

BASIC BRUSH ALPHABET / LOWERCASE

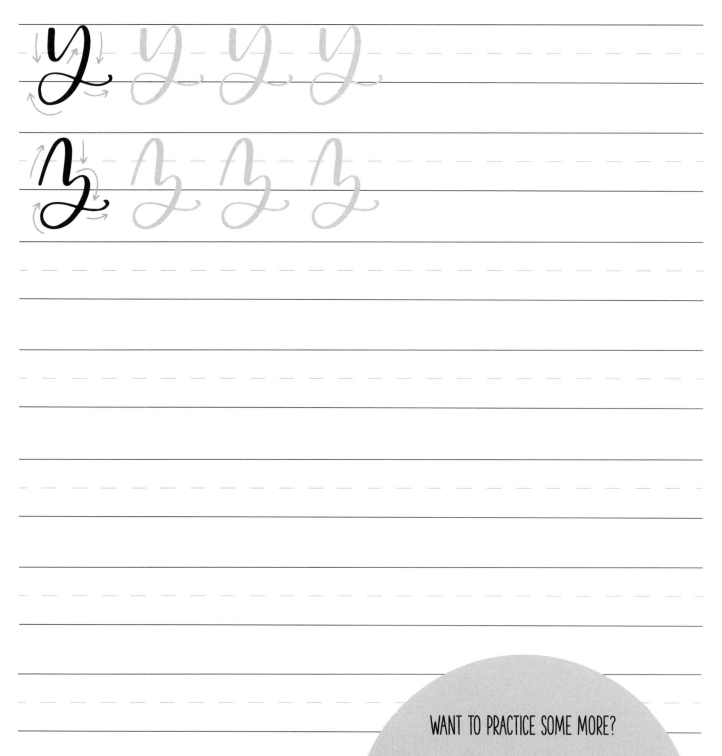

WANT TO PRACTICE SOME MORE?

Don't forget to sign up for my newsletter at www.junelucy.com/lettering and print out my free worksheets so you can keep practic- ing your letters. Try out your brush pens with a premium laser jet paper and notice the difference it makes with your strokes!

Life is TOO SHORT to be [ANGRY] with YOURSELF FOR BEING human

1. Go slow! Keep in mind as you are watching all those swoonworthy Instagram lettering videos, the majority of the time they are filmed in hyperlapse! Even the best letterers out there get that way by taking their time as they draw each stroke.

2. Practice makes progress. Still feel like your letters look shaky, uneven, and inconsistent? Congratulations, it sounds like you are right on track! Lettering is not something you are going to master overnight. It takes what feels like never-ending practice to perfect the skill, and even then, no one gets to the point of lettering perfect pieces every time they pick up a brush pen. Pencils and erasers are your friend - as well as stroke and letter drills. Muscle memory takes time to develop, but you will be amazed at how much progress you can make over time if you stick with it.

3. Hard pressure for downstrokes, light pressure for upstrokes!

4. Lift your pen at the end of each stroke. Lettering is not handwriting. I repeat, lettering is not handwriting. In fact, you can have horrible handwriting and still be an incredible letterer! Draw each stroke and find breaks in your letterforms where you can pick up your pen and contemplate your next stroke before you make it.

BASIC BRUSH ALPHABET: UPPERCASE

A B C D E F G

H I J K L M

N O P Q R S

T U V W X

Y Z

BASIC BRUSH ALPHABET / UPPERCASE

Use the guides to practice your letters by tracing my letters first, and then use the blank space to practice drawing them on your own.

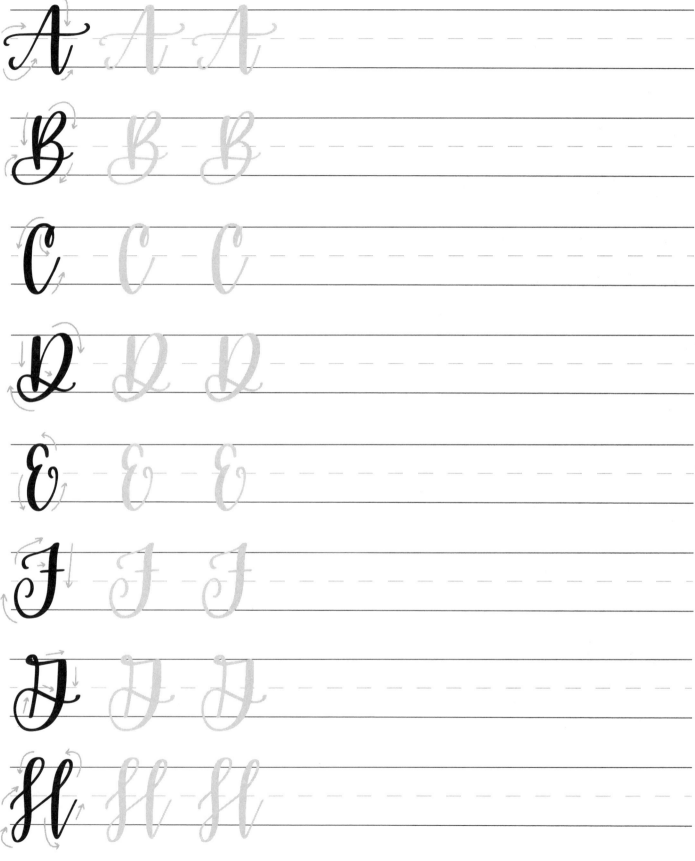

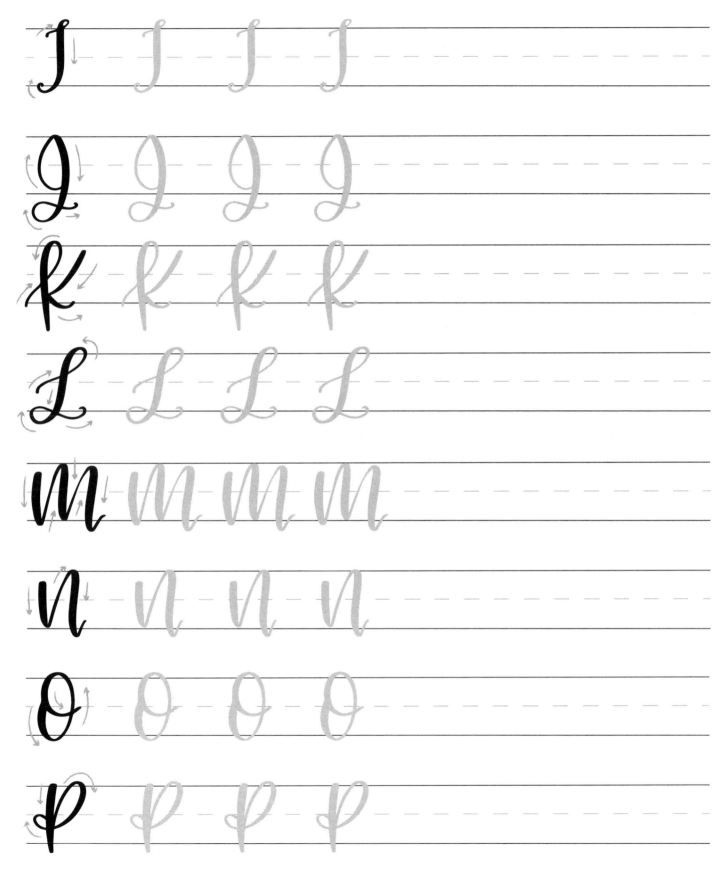

BASIC BRUSH ALPHABET / UPPERCASE

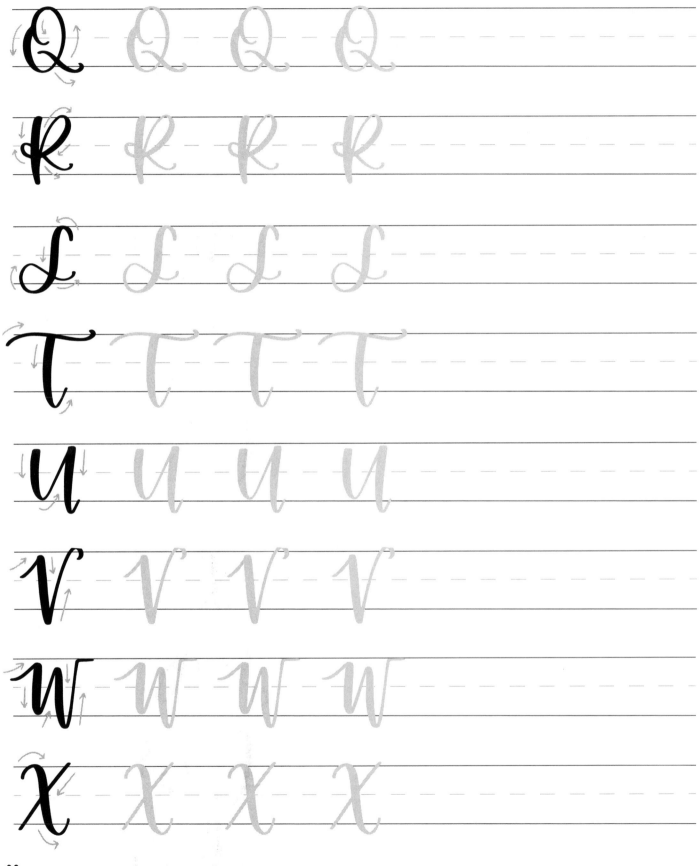

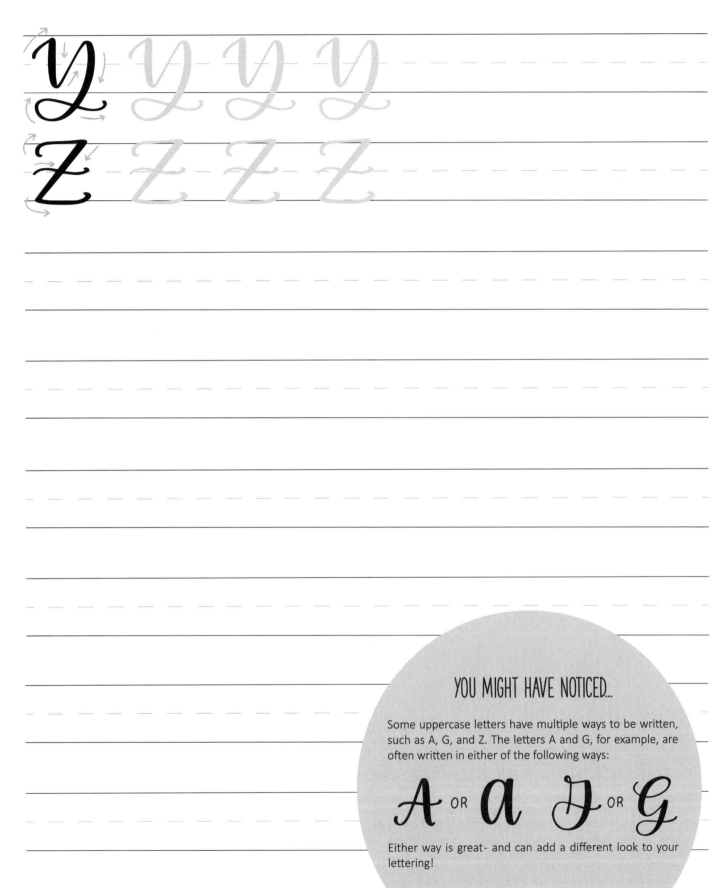

YOU MIGHT HAVE NOTICED...

Some uppercase letters have multiple ways to be written, such as A, G, and Z. The letters A and G, for example, are often written in either of the following ways:

A OR a G OR G

Either way is great- and can add a different look to your lettering!

A A B B C C
D D E E F F
G G H H I I
J J K K L L
M M N N O O
P P Q Q R R
S S T T U U
V V W W X X
Y Y Z Z

VARIATIONS

While the desire to achieve those beautiful brush lettered works of art was what originally got me interested in hand lettering, I quickly discovered the beauty of monoline lettering as well - and it soon became one of my favorite styles. If you remember from earlier in the book, you accomplish monoline lettering by using consistent pressure throughout the entire letter so that the width of your line is the same for all your strokes (no thick downstrokes and thin upstrokes here).

If you notice, this monoline alphabet is created using essentially the same letterforms as the Basic Brush Alphabet was - however the difference between monoline and brush lettering style results in an entirely different look.

The great thing about monoline lettering is that you can use any standard pen, pencil or marker with it. So put away those brush pens and pull out your favorite round tipped tool (I love using Micron pens or any pen designed for Monoline drawing). And again - a pencil works great here!

BASIC MONOLINE ALPHABET: LOWERCASE

a b c d e f g
h i j k l m
n o p q r s
t u v w x
y z

FAUX CALLIGRAPHY 101:

Monoline lettering is great for creating faux calligraphy. To achieve this look, you simply draw your monoline letter or word, and then add a secondary line to each of your downstrokes and fill in the space between (or leave it open for a fun look all of its own!)

BASIC MONOLINE ALPHABET / LOWERCASE

Use the guides to practice your letters by tracing my letters first, and then use the blank space to practice drawing them on your own.

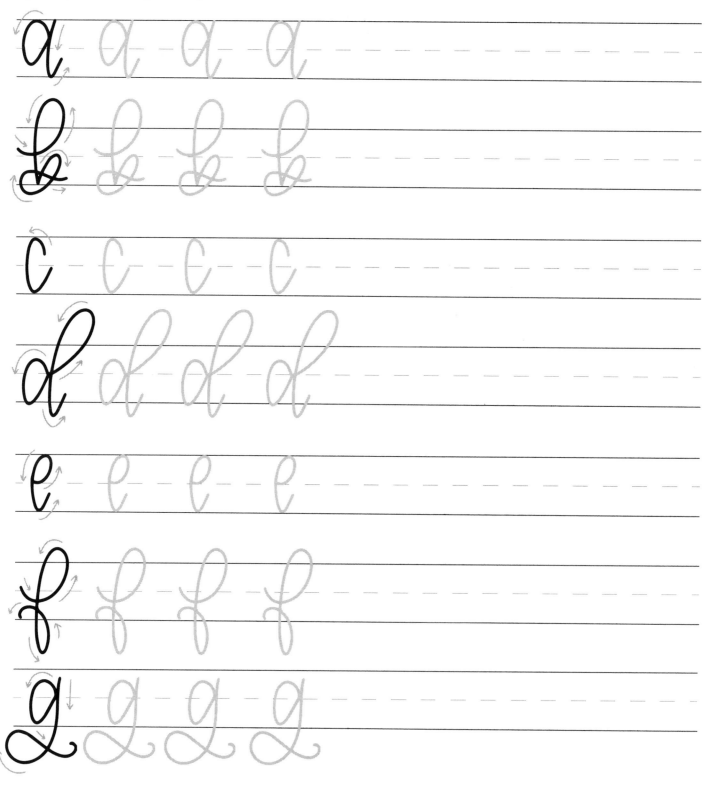

Remember to stop and pick up your pen after every stroke, even with letters like "d" and "g'", where you might be tempted to use a single stroke. Stop and pick up your pen after creating the oval portion of both letters before starting the next stroke.

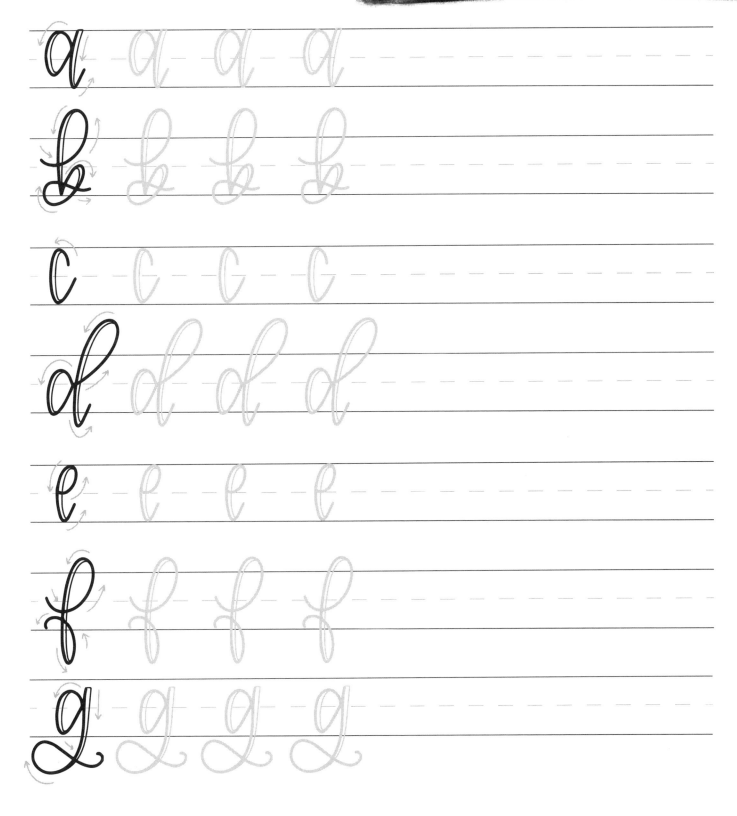

BASIC MONOLINE ALPHABET / LOWERCASE

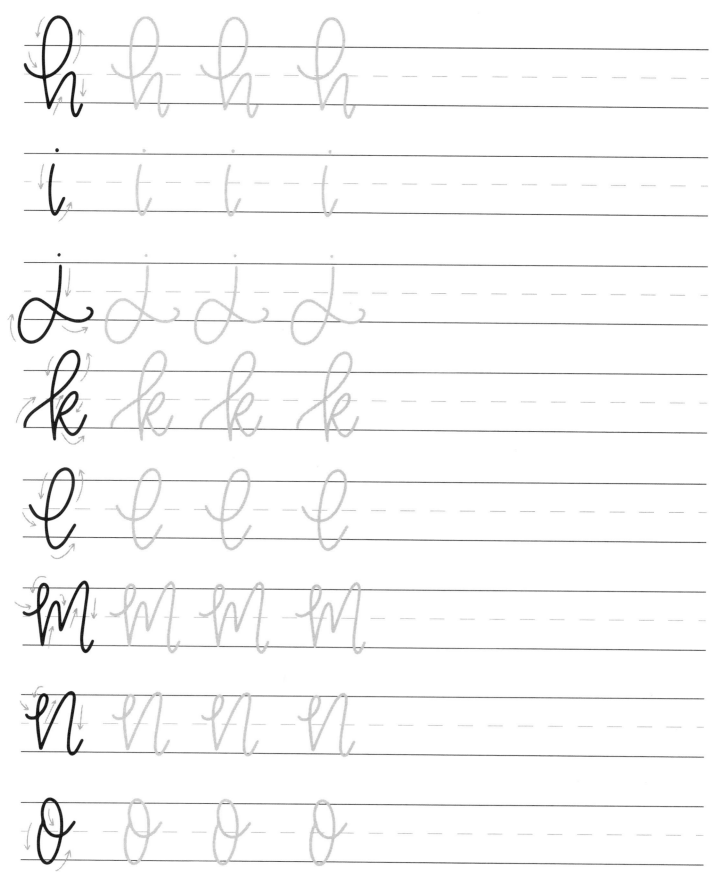

h h h h h

i i i i

j j j j j

k k k k

l l l l

m m m m m

n n n n

o o o o

BASIC MONOLINE ALPHABET / LOWERCASE

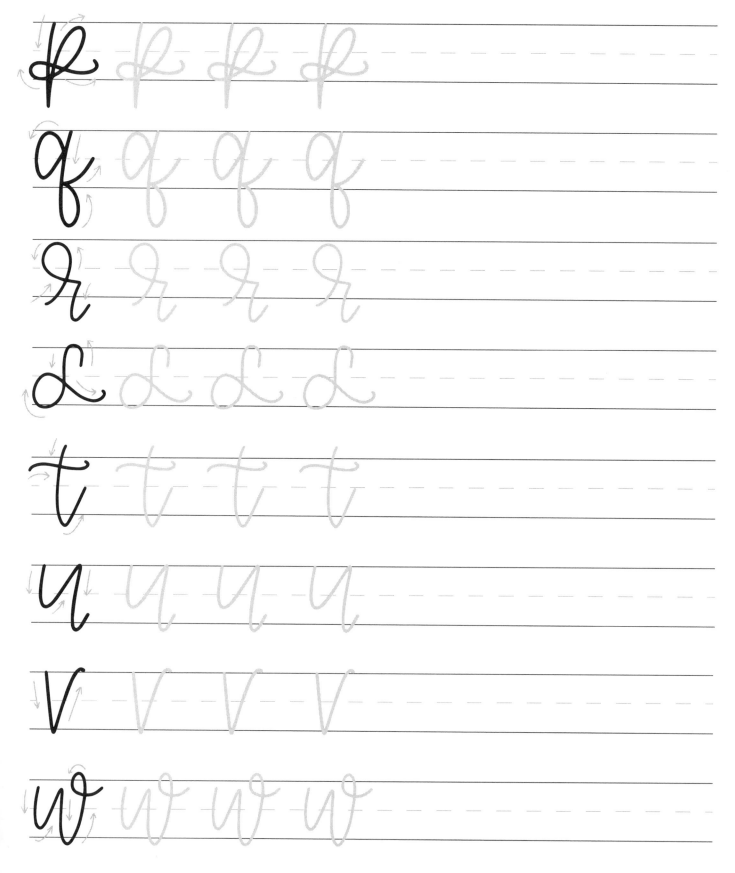

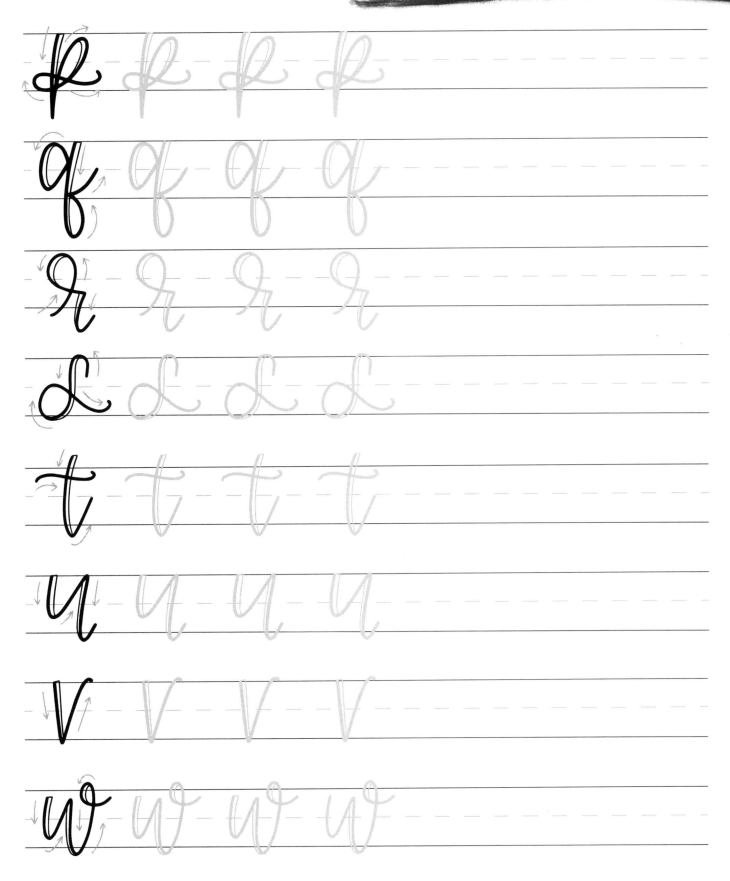

BASIC MONOLINE ALPHABET / LOWERCASE

x x x x

y y y y

z z z z

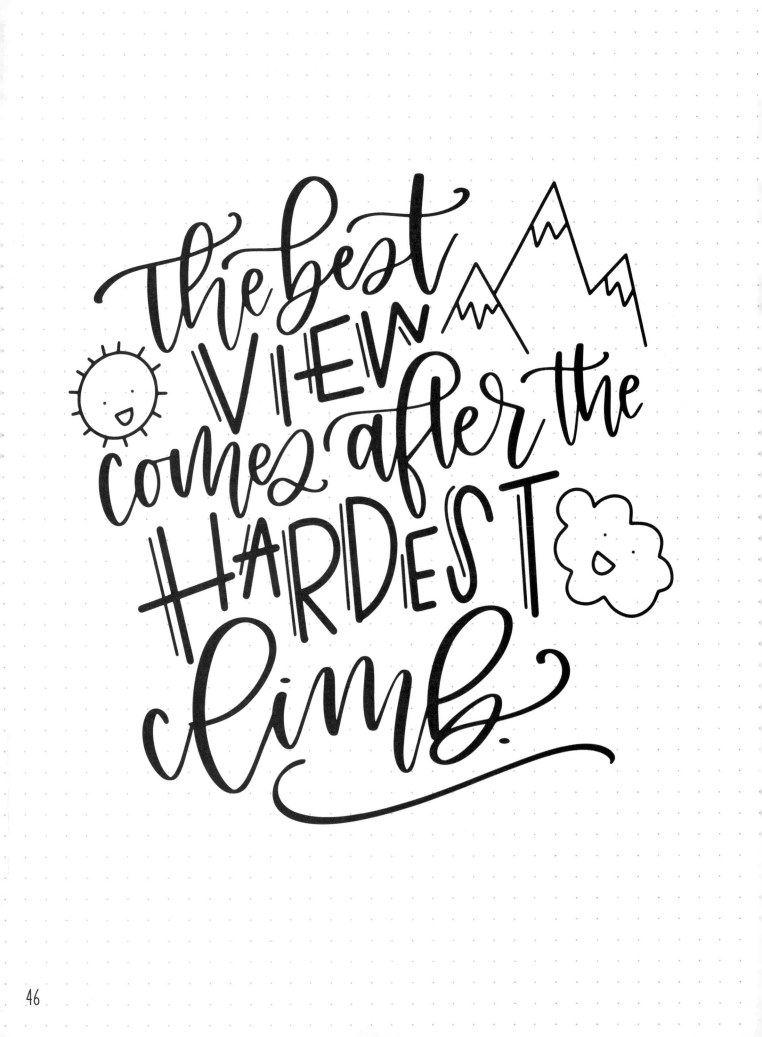

the best view comes after the HARDEST climb.

1 You can achieve a completely different look with your monoline lettering by using a different size pen. Broader barrel tipped pens/markers are great for chunky lettering, whereas finer tipped pens/markers are great for doing more delicate lettering.

2 Try to maintain a similar style with your swashes (which will ultimately become connections), flourishes and loops within a single alphabet. Rounded swashes are great, as are angular ones, but you want to be careful about mixing multiple styles or it can look sloppy when you start forming words. Here is an example for your reference:

3 Don't grip your pen/pencil too tight! If your hand starts to cramp up, step back and take a break- and make sure you never see any sign of white knuckles. A loose grip makes for better lettering!

☑ *smooth* Rounded connections

☑ *sharp* Angular connections

☒ *mixed* Both connections

BASIC MONOLINE ALPHABET : UPPERCASE

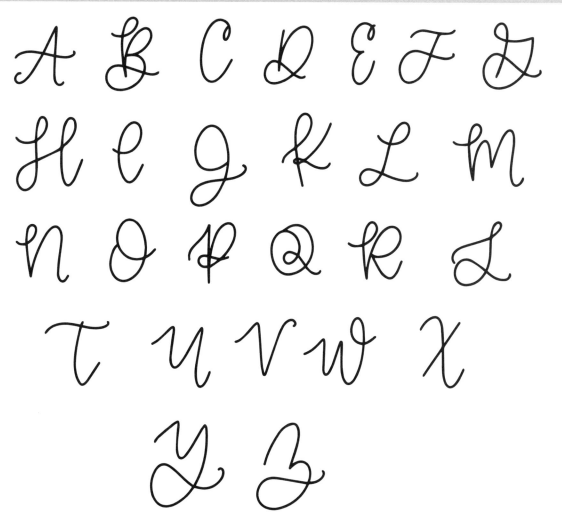

47

BASIC MONOLINE ALPHABET / UPPERCASE

Use the guides to practice your letters by tracing my letters first, and then use the blank space to practice drawing them on your own.

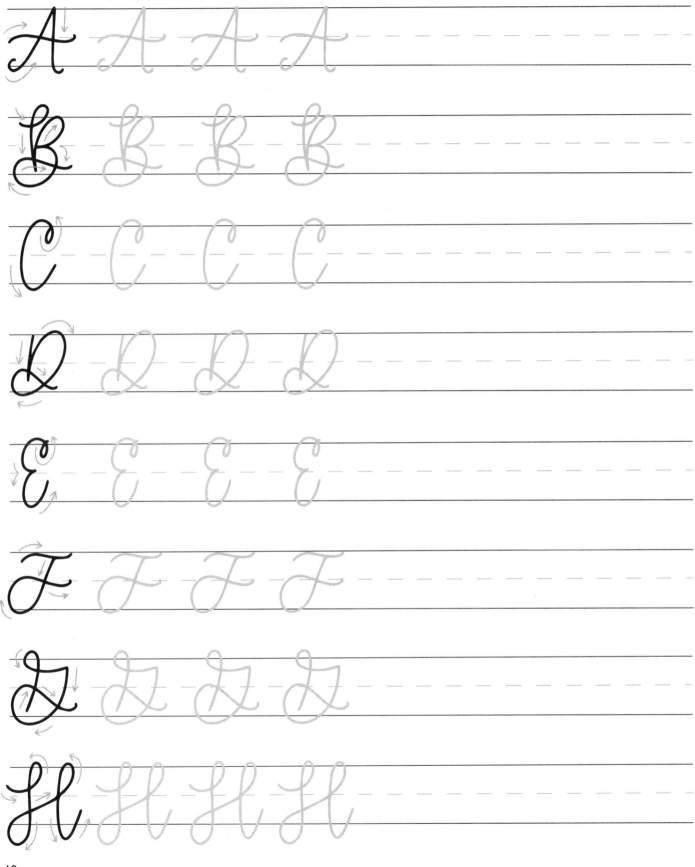

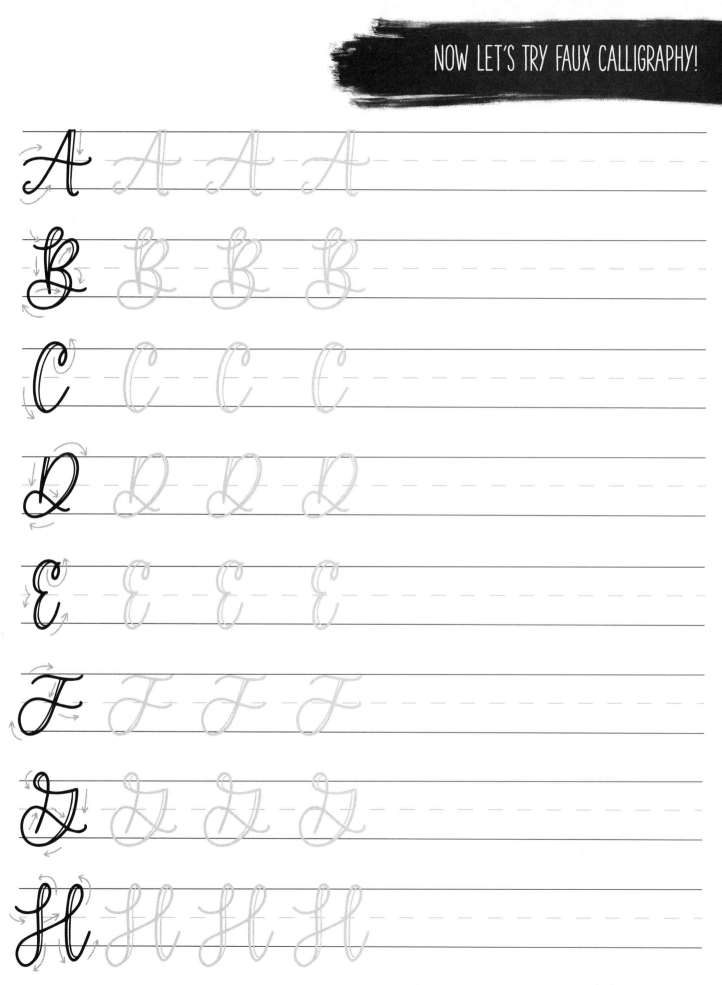

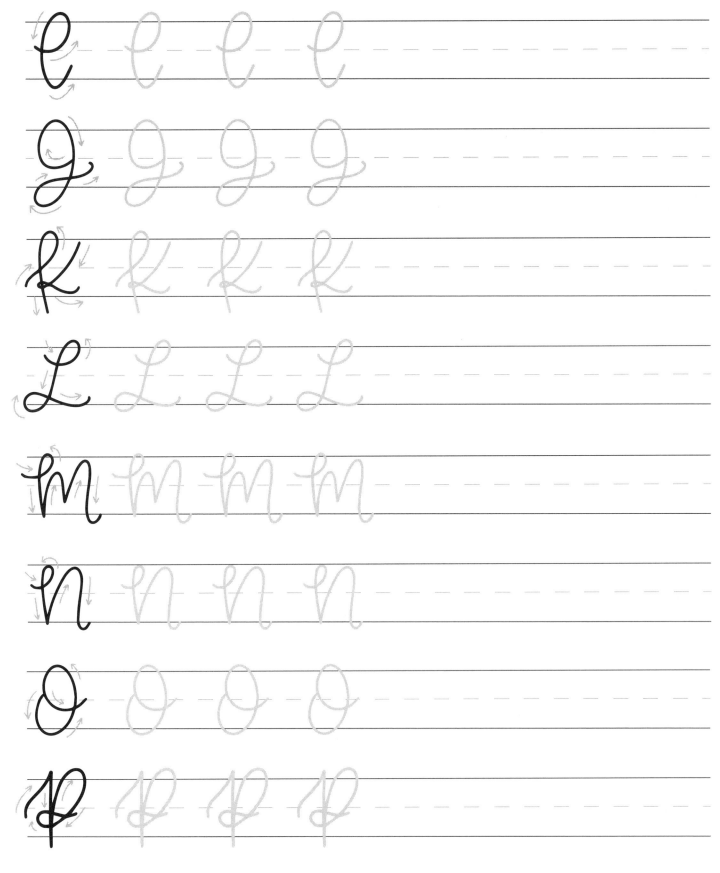

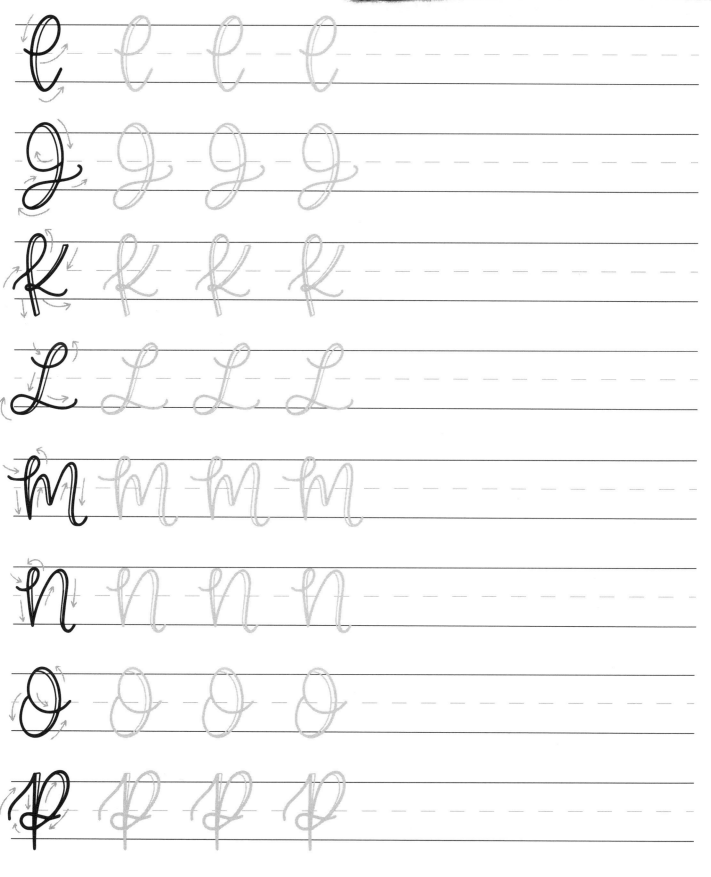

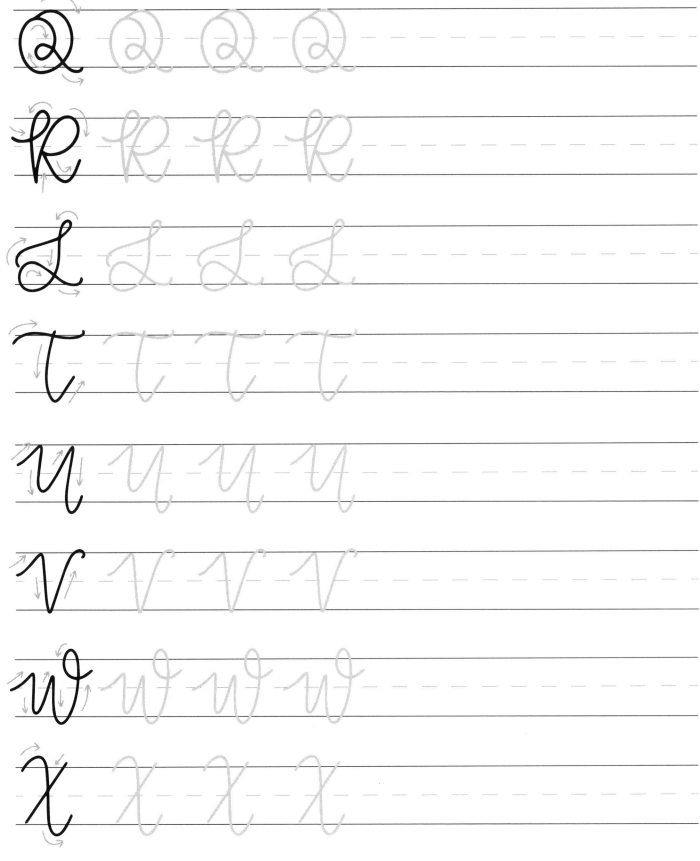

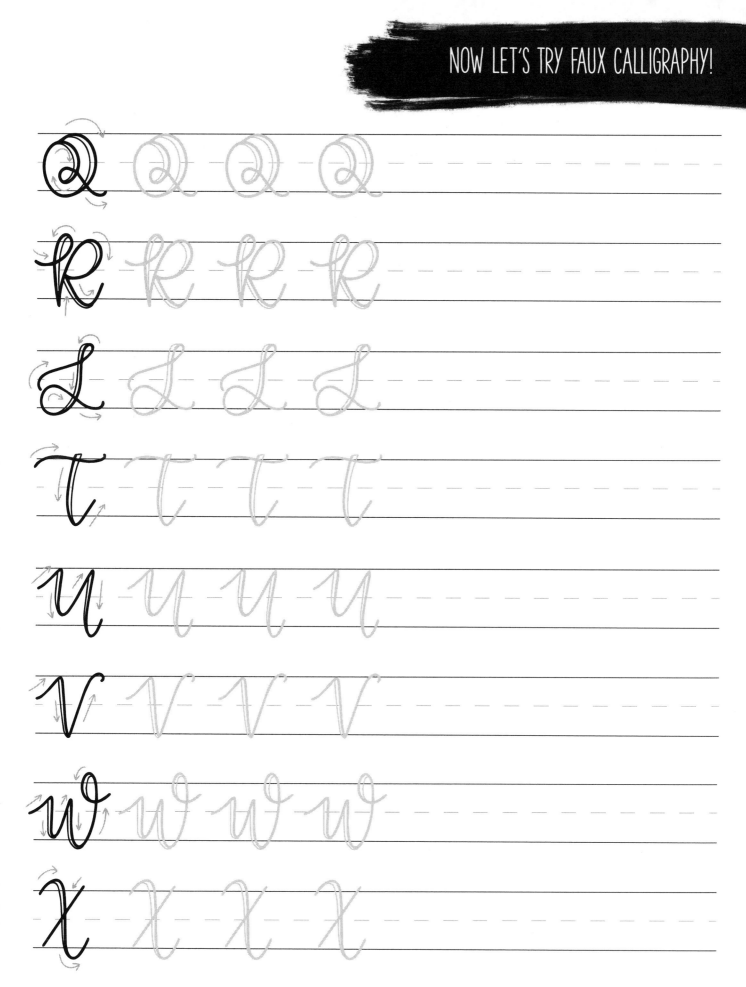

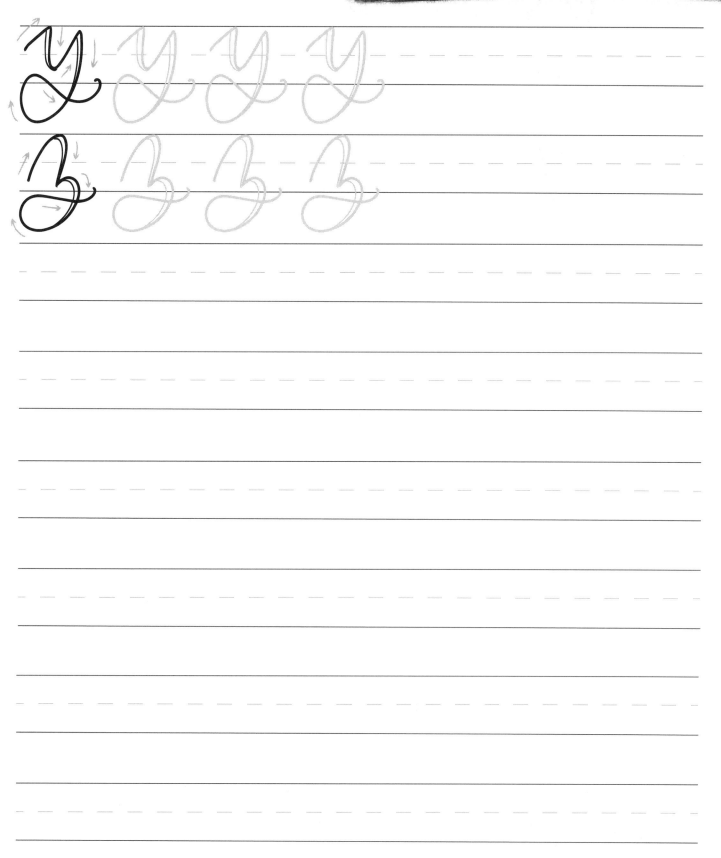

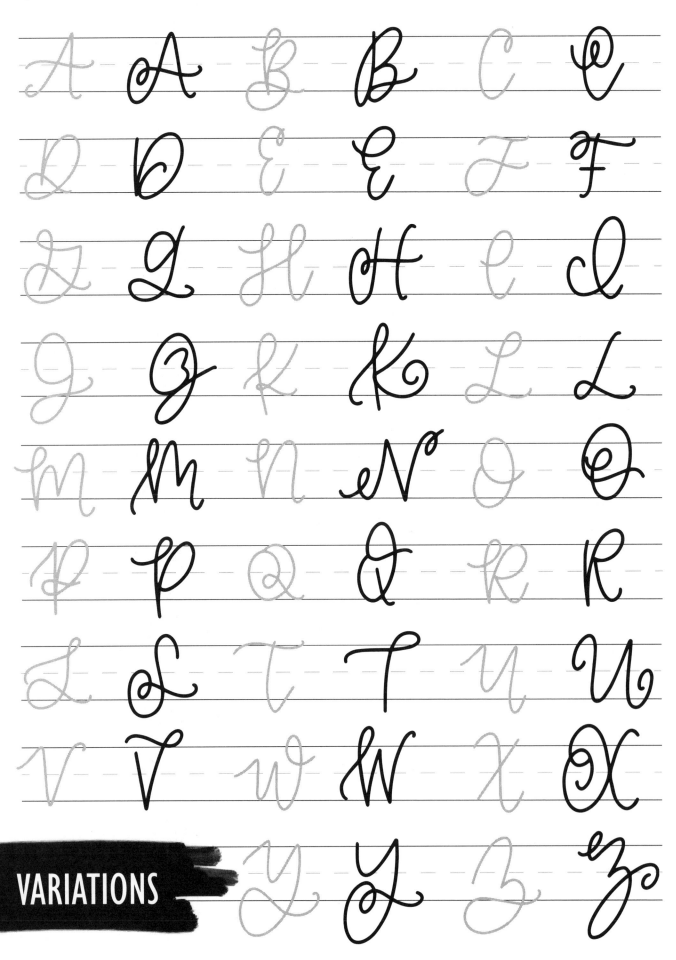

56

♡ connections & words

CONNECTING LETTERS TO FORM WORDS

Now that you have gotten the hang of drawing your letters, let's work on connecting those individual letters to form your words.

This section could in all honesty be titled "Connecting Strokes to Form Words", since that is the best way to think about how you hand letter a word. At the end of a stroke, pick up your pen and think about how your next stroke will connect to the next letter. There will be some parts of a word where you connect two letters without stopping, since the two letters are connected by a continuous stroke. An example of this is how the "e" and the "r" connect below, with the tail of the "e" going right into the loop of the "r", or how the second stroke of the "d" flows continuously to create the "s".

Here are a few examples to show the breakdown of the strokes as they form letters and are combined into words.

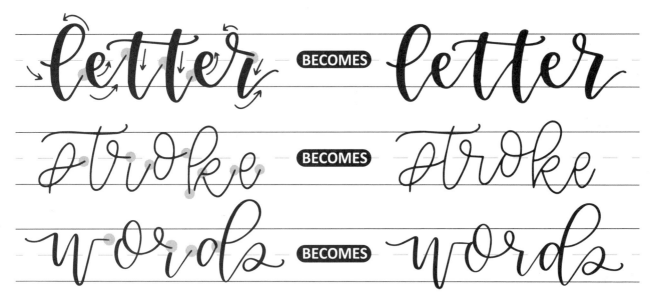

SOME TIPS TO CONSIDER:

1 Remember, lettering is not cursive. If you find yourself writing your entire word out without stopping at the end of your strokes, you will end up with cursive. And although cursive is beautiful, I am guessing you did not buy this book to teach you how to write it. Here is an example of a word that was one fluid motion (i.e., cursive), and then a word that was hand lettered. *millenium* vs *millenium*

2 Before lettering your word, look at where you have cross strokes, and how you can use those to connect to other letters in the word. PRO TIP: the letters do not need to be right next to each other to accomplish this. Here is an example of the cross stroke of the "t" forming the ascender of the letter "h".

3 If your letter has a descender, you can opt to have it end with a long tail or a flourish instead of connecting to the next letter. As with any flourish though, use this sparingly so it doesn't over complicate your design.

Use the guides to practice connecting your letters by tracing my connections first, and then use the blank space to practice drawing them on your own.

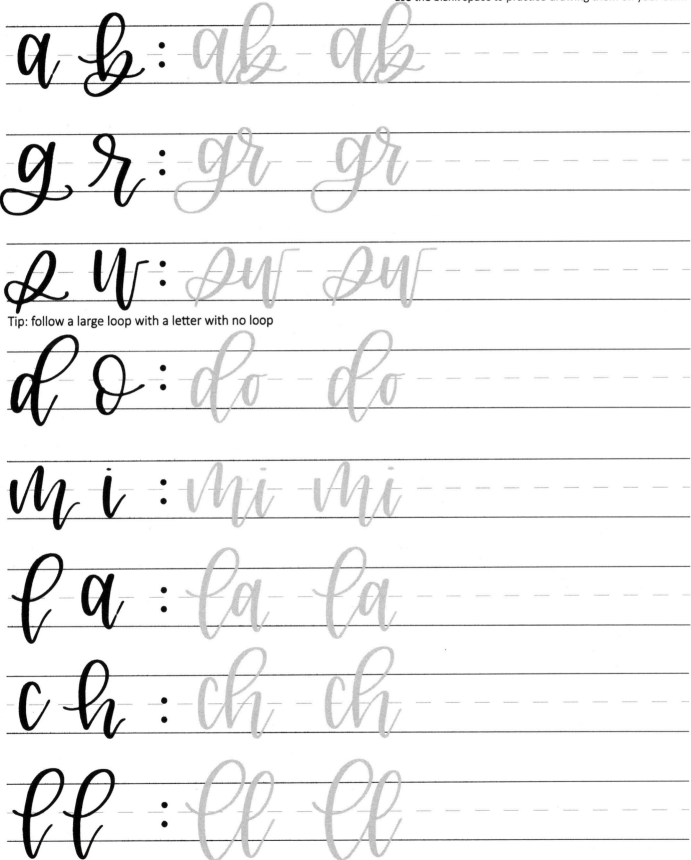

a b : ab ab

g r : gr gr

a u : au au

Tip: follow a large loop with a letter with no loop

d o : do do

m i : mi mi

l a : la la

c h : ch ch

ll : ll ll

CONNECTING LETTERS

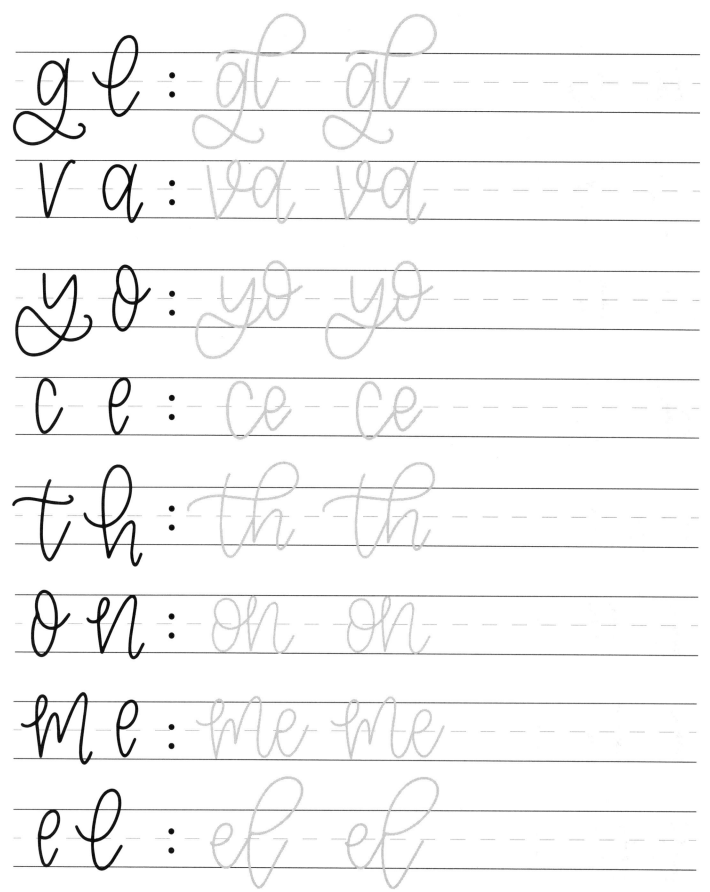

g l : gl gl

v a : va va

y o : yo yo

c e : ce ce

t h : th th

o n : on on

m e : me me

e l : el el

Tip: Reduce the size of the "E" and enlarge the size of the "L" to ensure they don't look like the same letter

h i :

p r :

s t :

o m :

b o :

l i :

g y :

e x :

BASIC BRUSH LETTER WORDS

Use the guides to practice your letters by tracing my words first, and then use the blank space to practice drawing them on your own.

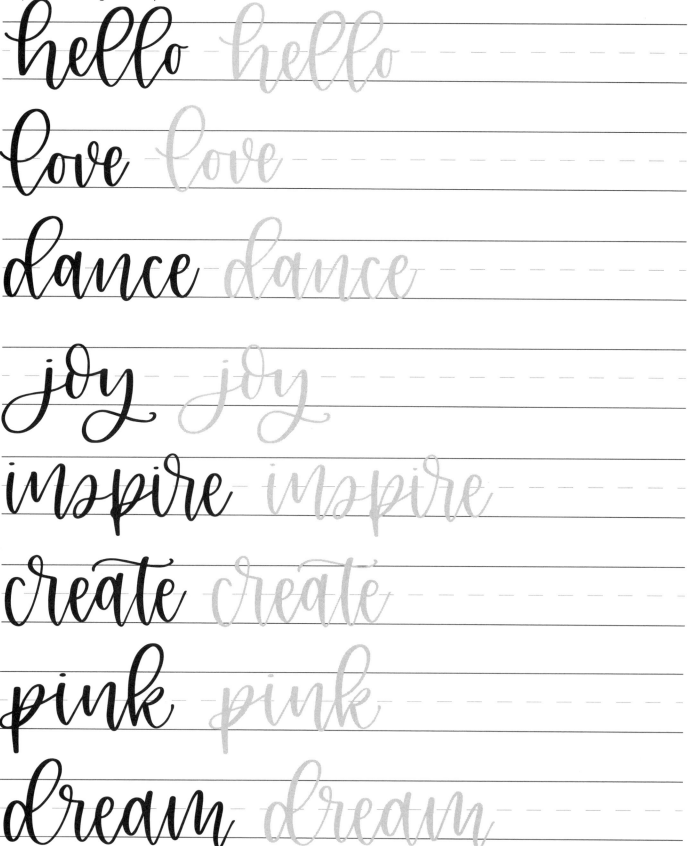

hello hello

love love

dance dance

joy joy

inspire inspire

create create

pink pink

dream dream

BASIC BRUSH LETTER WORDS

Christmas *Christmas*

birthday *birthday*

holiday *holiday*

thanks *thanks*

grace *grace*

donuts *donuts*

home *home*

enjoy *enjoy*

BASIC BRUSH LETTER WORDS

beautiful beautiful

sweet sweet

llama llama

girl girl

free free

wine wine

work work

tacos tacos

BASIC MONOLINE LETTER WORDS

girl girl

bear bear

beach beach

shine shine

home home

grateful grateful

cactuz cactuz

live live

BASIC MONOLINE LETTER WORDS

light *light*

congrats *congrats*

smile *smile*

welcome *welcome*

darling *darling*

garden *garden*

cat *cat*

dog *dog*

BASIC MONOLINE LETTER WORDS

hooray

awesome

plant

grow

read

alive

season

light

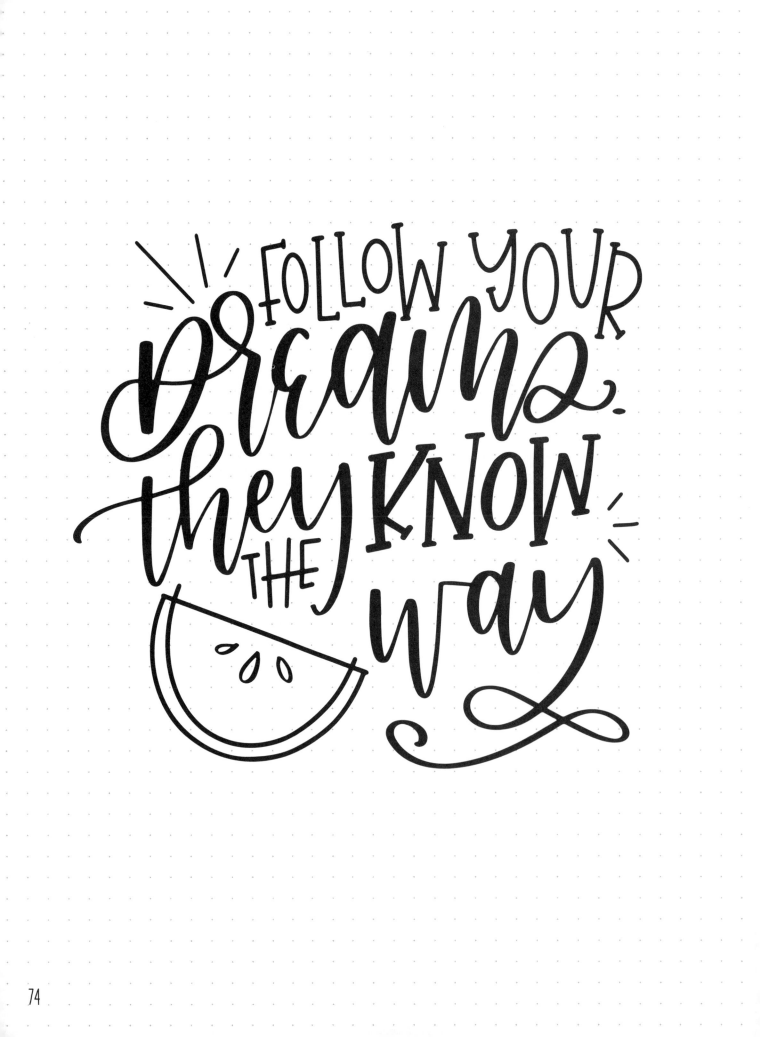

♡ variation

& ILLUSTRATIONS

A B C D E F G H I
J K L M N O P Q R
S T U V W X Y Z

a b c d e f g h i
j k l m n o p q r
s t u v w x y z

A B C D E F G H I
J K L M N O P Q R
S T U V W X Y Z

♡

a b c d e f g h i
j k l m n o p q r
s t u v w x y z

There are countless ways to modify each letter, and the ability to be flexible with your strokes and make variations with the shapes of your letters (even in subtle ways) is what will set your lettering apart. It is one thing to learn how to draw the exact same letterform over and over, even to perfect that letterform! But at the end of the day, that is what a good font on your computer can do, and that is not what lettering is about.

To hand letter beautiful pieces, you need to think about the finished piece as a whole, which means modifying your letters to fill empty space as appropriate. On the variation pages I have provided previously in the book, I have shown you one of many ways I like to vary each letter. Let's break down the various ways you can think about your letters and how you can take a stab at modifying them in your own way:

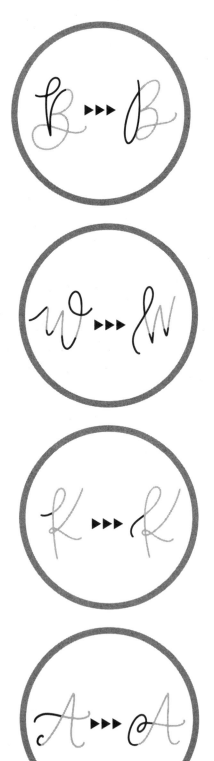

1 Change the style of the swash that starts the letter at the beginning of the word. See how each of the examples to the right have a different swash leading into the letter. You can add loops, start with a swash curved down vs. curved up, combine the swash with the cross stroke, or even eliminate the swash all together and start with a plain stem. You can do the same with the swash that ends a letter that doesn't connect to the next letter, as I have done with the W to the right.

2 Exaggerate the "bounce" in your lettering (sometimes referred to as the "bouncy" lettering style) by making the bowls, eyes and curves in your letters rounder and using bigger loops and flourishes. Think round, not angular. Notice the difference between the W's and how the lower peaks of the W to the right hits the baseline.

3 Form a ligature with your cross strokes between two letters such as the "t" and the "h". In other words, use your cross stroke of one letter to lead into or become part of another letter in your word (you will see some examples of this in our upcoming word practice, so keep your eye out for it).

4 Be flexible with how your letters rest on the baseline and decrease the size of some of your letters. Unlike with traditional calligraphy, which utilizes the baseline, cap line, and midline rather strictly, with modern calligraphy you can be more flexible with where you letters sit on these guides. Just make sure your word stays balanced- otherwise you can end up with a word that appears to slant upwards or look too wavy.

5 Add flourishes - but sparingly! Less is more when it comes to flourishes, otherwise they can quickly overwhelm your lettering. You usually use flourishes on the first and last letters of a word, but you can also use them on letters with ascenders, descenders or cross strokes.

Mixing different font styles is one of my favorite parts of hand lettering. Contrast is the key here, since you don't want to mix two styles that look similar enough to make someone think you just got sloppy with your consistency. If one font style is super whimsical and flowy, try a more structured and simpler counterpart. Or if one style is really bold, combine it with a thin and delicate secondary style.

Here are some of my favorite combinations to mix together in my lettering pieces to get you started:

monoscript
UPPERCASE SERIF

BOLD SAN SERIF
Bouncy Brush

Basic Brush
SKINNY SAN SERIF

UPPERCASE SAN SERIF
bold monoscript

Flourishes are great to use with any letters at the beginning or end of a word, or letters that have an ascender, descender, or cross stroke.

Fun fact, flourishes were one of the hardest parts of hand lettering for me to get the hang of. And I still struggle with them if I haven't been practicing the movements. This is because of all the techniques of hand lettering, flourishes take the most muscle memory due to the continuous fluid movement that is required. This may be a difficult skill for you to pick up on, and that is ok! You can create beautiful lettered pieces without ever using a flourish. But if you want to take on the challenge of adding these gorgeous additions to your lettering pieces, here are some tips and tricks:

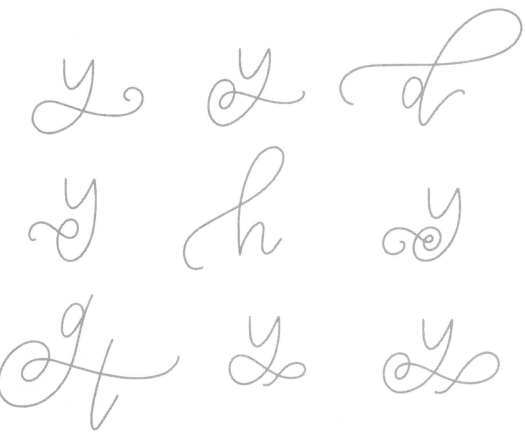

1. Loose grips on that pen, pencil or brush! The key with flourishes is smooth, fluid movements. If you are holding your tool too tight, or dragging your palm too hard against your paper, then your flourish is likely to suffer and become shaky.

2. Practice, practice, practice! Practice your various strokes and loops until they become second nature. Sometimes you will do a flourish that just looks off and doesn't work. That is ok! Look at what part of it went awry (maybe you swooped up when you should have swooped down) and try to change that part of the flourish going forward.

3. As with other enhancements to your lettering, you don't want to overdo it with flourishes. If you flourish a piece in every spot that you possibly can, you will end up with a swirly mess that is likely difficult to read. Make sure they are adding to your piece, and not overcomplicating it.

FLOURISHES & SWASHES

Use the guides to practice your flourishes by tracing mine first, and then use the blank space to practice drawing them on your own.

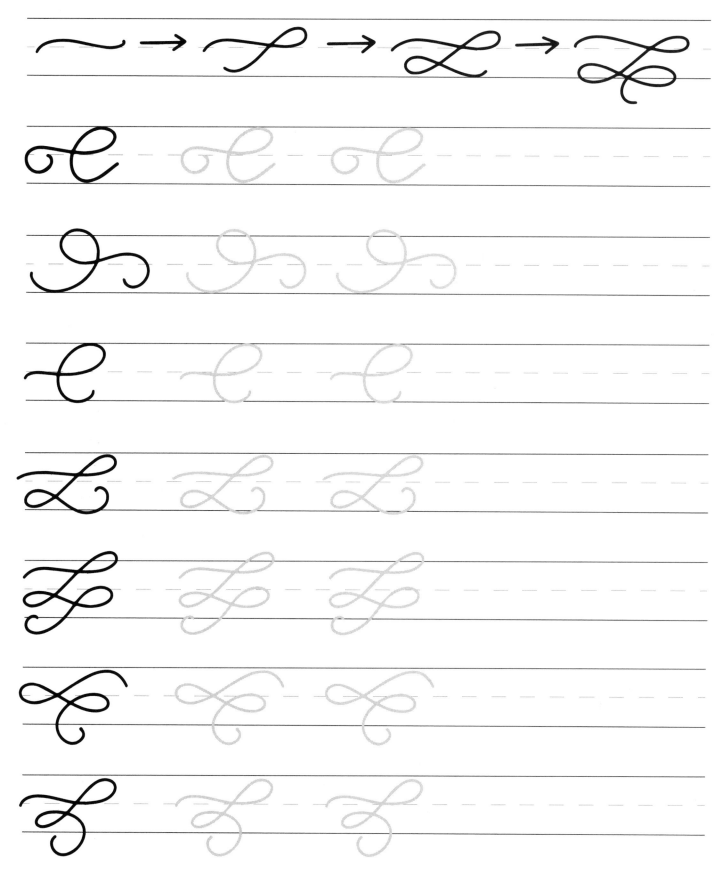

hello

dream

grace

lady

light

hello

dream

grace

lady

light

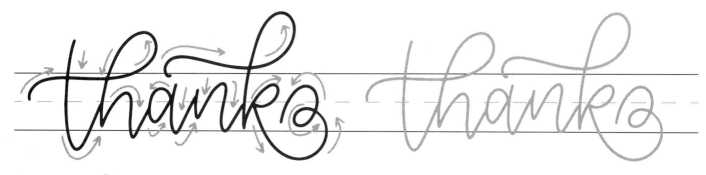

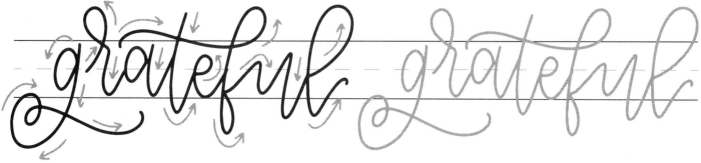

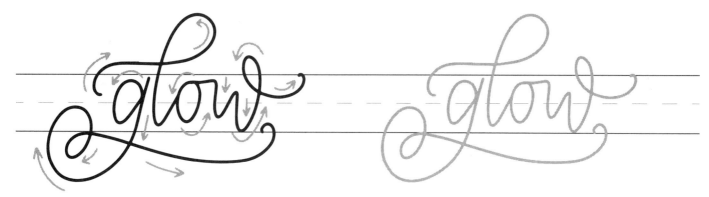

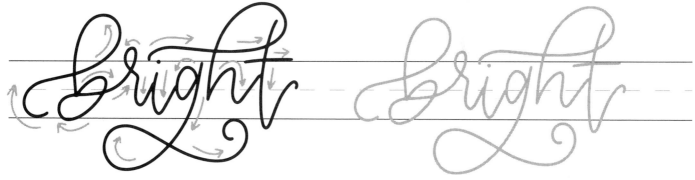

BOTANICAL LINE DRAWINGS

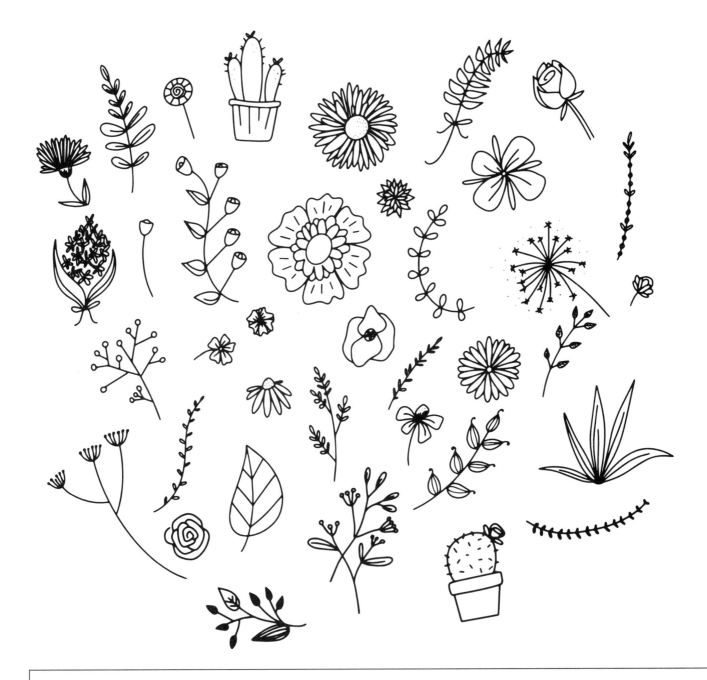

Adding botanical elements are a great tool for adding accents to your lettering pieces, especially when it comes to filling in negative space in your design. Here are some examples of the types of botanical elements that I like to include in my pieces, but as with other concepts addressed in this book, the possibilities are endless when it comes to botanical line drawings. Use some blank paper and a fine mono pen (such as a Micron) or a pencil and get your creative juices flowing by filling the page with your own botanical line drawings.

RIBBONS AND BANNERS

BANNER TIPS AND TRICKS

Add accents to your ribbons and banners, such as small botanical elements coming out from behind them, or dashed or dotted lines to look like stitching.

Use thin parallel lines, cross hatches, or stippling to give the appearance of a shadow to provide some depth to your banners. Apply the effect where you are trying to show the "back" of the ribbon.

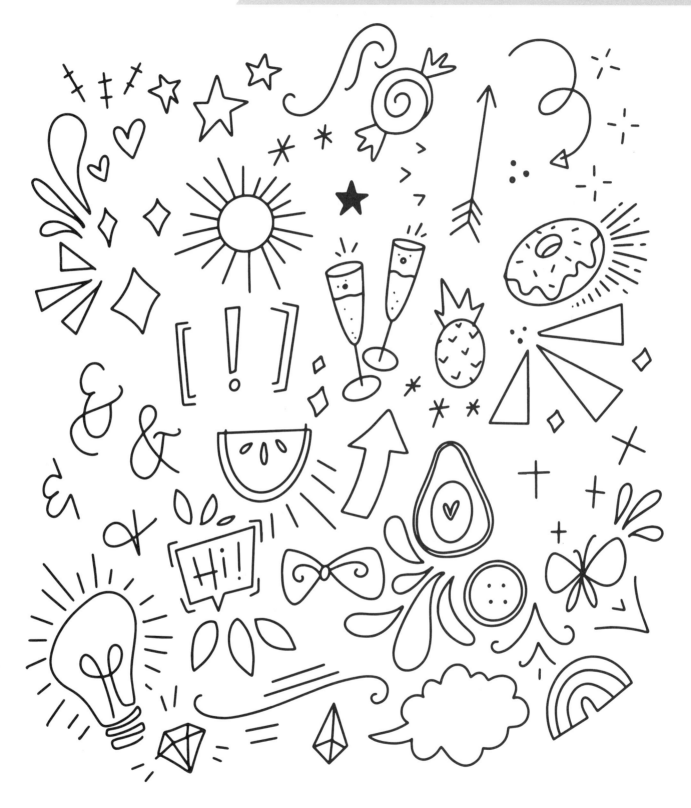

HELPFUL TIP! When you are feeling stuck, or you feel like you are in a creative rut, make a list of everyday objects, and come up with your own doodle variations of them. As seen here, my illustrations are generally very simple, so that they add to my lettering piece without taking it over.

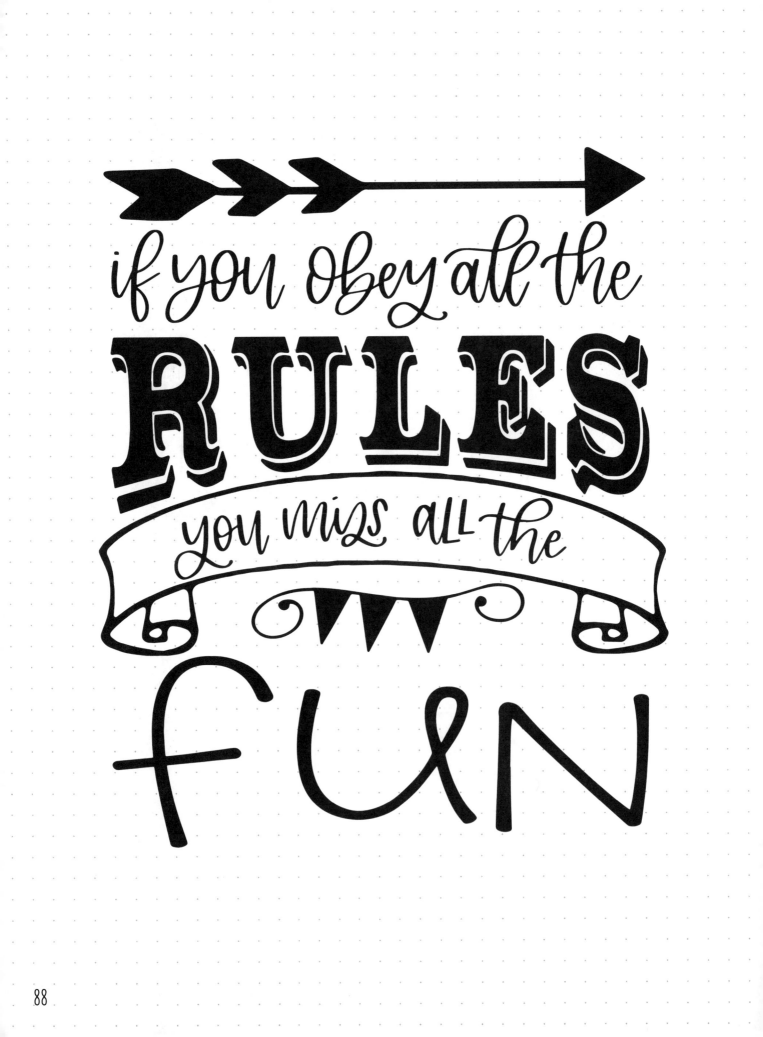

if you obey all the **RULES** you miss all the FUN

♡ design
COMPOSITION

Congratulations! You have made it all the way to the final stage - composing a hand lettered design. Here is where you will take everything you just worked through and learn the basic steps to putting them all together to create a finished piece.

The first thing I will say is that with regard to designing, you can feel free to take what I say with a grain of salt. These are merely suggestions, like "dry clean only". You will ultimately come up with your own way that you want to design pieces, but hopefully you will get there armed with the basics you have learned from this book.

To help you as you start to compose your own pieces, here are the steps I go through when I create a finished piece, as well as a few tips and tricks to help you along.

1 I always start by writing out the word or phrase I want to letter on a piece of scratch paper. This lets me see all of the letters together, so I can start to identify what the focus words are, and where there are ascenders, descenders, and cross strokes, that I can use in the composition of my design.

2 Once I have a feel for the components of the phrase, I lightly sketch out my focus word(s) in pencil. These are the words you want to stand out the most. Be sure to use light pressure with your pencil when sketching- while you can always erase the pencil marks, you can't remove any indentations you may have made in the paper from pressing too hard.

3 Once you have your focus words sketched out, you can identify where the rest of the words will fit into the design. Look for negative space that they might fit into, whether they work best directly on top of or on bottom of the focus words, etc. Always pay attention to your placement, and make sure that wherever you decide to draw in the rest of the words, the phrase as a whole can still be easily read.

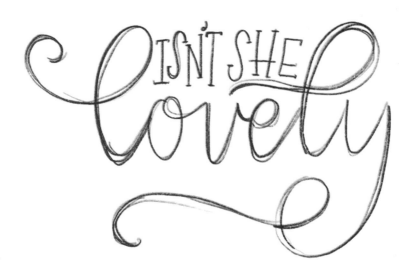

Now you can sketch in any botanicals, florals, or illustrations you want to fill in any negative space. Watch where you add these enhancements to make sure they do not throw your design out of balance.

4

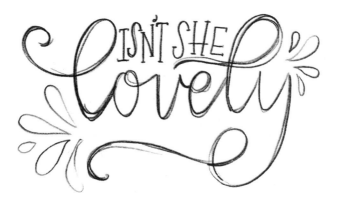

Only when I have my entire design sketched out do I turn to ink. Depending on the style of lettering you are going for, this may be either your brush pen or your monoline pen. Always ink the design in the same order you sketched it, starting with your focus words, then the rest of your phrase, and finally the enhancements. Your inking may not always line up exactly with your pencil, but you want to make sure you are still always building the design around the focus words.

And there you have it - your finished design!

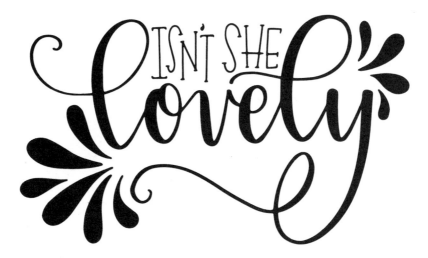

Now it is time to try your hand at lettering a few composed pieces. I have provided eight simple hand lettered designs on the remaining pages for you to try to duplicate. Don't forget to download and print your free worksheets so that you can keep practicing your strokes and letters. Hand lettering is about muscle memory and control, and just as my seventh grade Spanish teacher told me, use it or lose it.

But most importantly - have fun with it! Get creative, try new styles, and over time you will likely even develop your own.

Share your finished lettering pieces with me on Instagram by tagging me @Juneandlucy - I would absolutely love to see what you creative geniuses come up with!

FINAL DESIGN / CREATE TO INSPIRE

Start by tracing my design below in the following order: focus words, remaining words, and then illustrations and doodles.

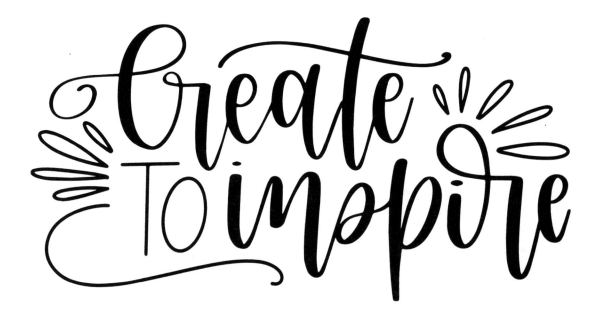

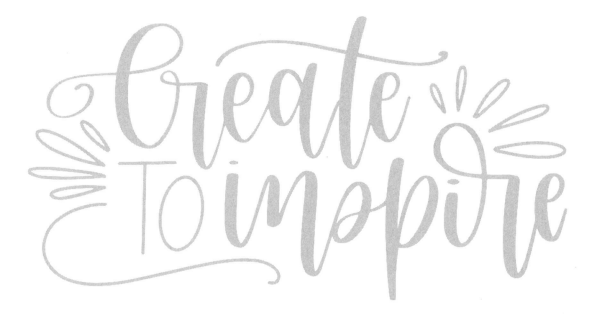

NOW TRY TO DUPLICATE MY DESIGN WITHOUT ANY GUIDES!

AND FINALLY, LETTER THE PHRASE IN YOUR OWN STYLE!

Start by tracing my design below in the following order: focus words, remaining words, and then illustrations and doodles.

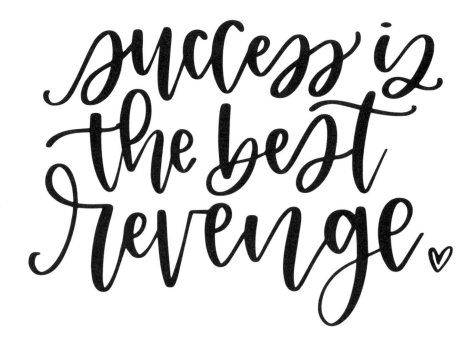

NOW TRY TO DUPLICATE MY DESIGN WITHOUT ANY GUIDES!

AND FINALLY, LETTER THE PHRASE IN YOUR OWN STYLE!

FINAL DESIGN / BE FEARLESS

Start by tracing my design below in the following order: focus words, remaining words, and then illustrations and doodles.

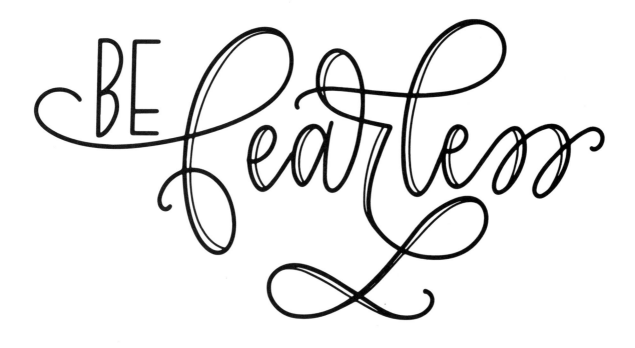

NOW TRY TO DUPLICATE MY DESIGN WITHOUT ANY GUIDES!

AND FINALLY, LETTER THE PHRASE IN YOUR OWN STYLE!

FINAL DESIGN / HELLO BEAUTIFUL

Start by tracing my design below in the following order: focus words, remaining words, and then illustrations and doodles.

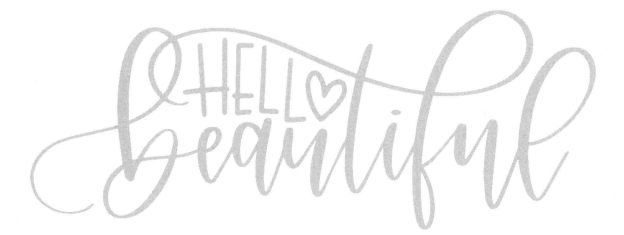

NOW TRY TO DUPLICATE MY DESIGN WITHOUT ANY GUIDES!

AND FINALLY, LETTER THE PHRASE IN YOUR OWN STYLE!

Start by tracing my design below in the following order: focus words, remaining words, and then illustrations and doodles.

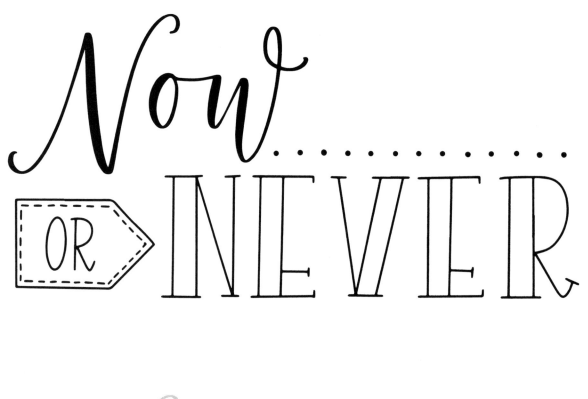

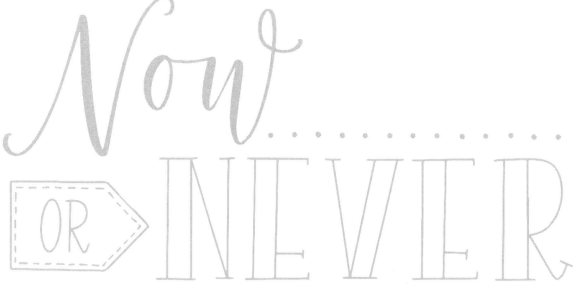

NOW TRY TO DUPLICATE MY DESIGN WITHOUT ANY GUIDES!

AND FINALLY, LETTER THE PHRASE IN YOUR OWN STYLE!

FINAL DESIGN / HOME SWEET HOME

Start by tracing my design below in the following order: focus words, remaining words, and then illustrations and doodles (NOTE: sometimes with wreaths it is easier to draw the wreath in pencil first so you have the shape outlined).

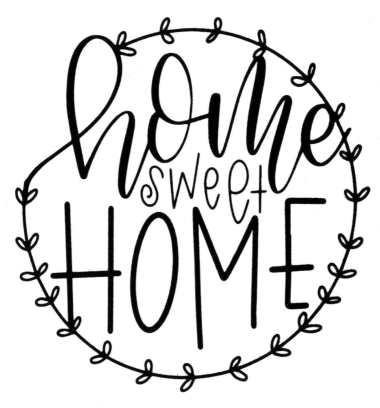

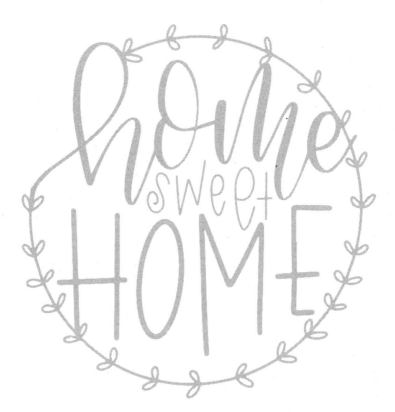

NOW TRY TO DUPLICATE MY DESIGN WITHOUT ANY GUIDES!

AND FINALLY, LETTER THE PHRASE IN YOUR OWN STYLE!

FINAL DESIGN / YOU'VE GOT THIS

Start by tracing my design below in the following order: focus words, remaining words, and then illustrations and doodles. (NOTE: remember to sketch in pencil first- this one is a bit more complicated since the descender of the "y" forms the cross stroke of the "t" and the ascender of the "h")

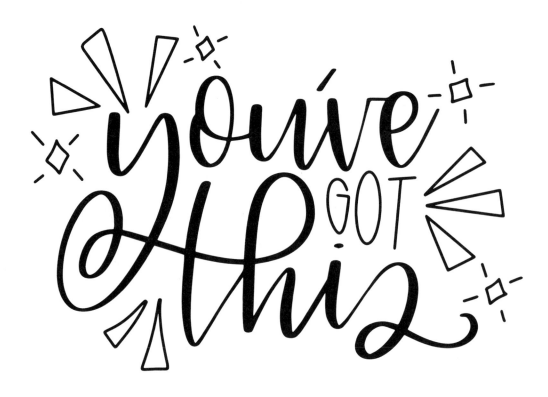

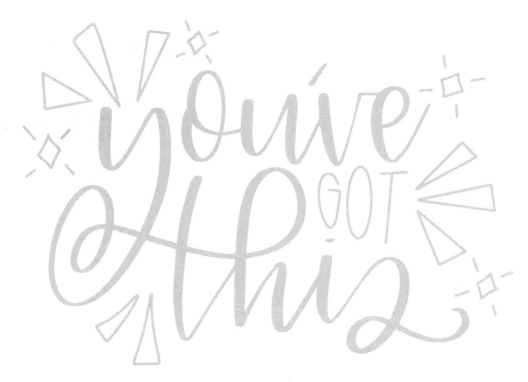

NOW TRY TO DUPLICATE MY DESIGN WITHOUT ANY GUIDES!

AND FINALLY, LETTER THE PHRASE IN YOUR OWN STYLE!

FINAL DESIGN / THE TIME IS NOW

Start by tracing my design below in the following order: focus words, remaining words, and then illustrations and doodles.

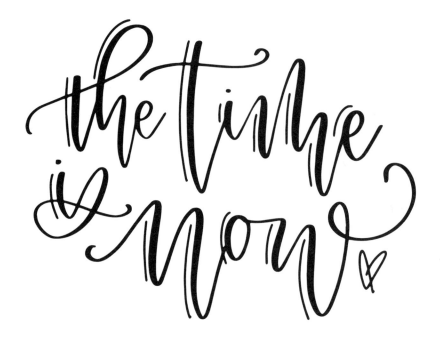

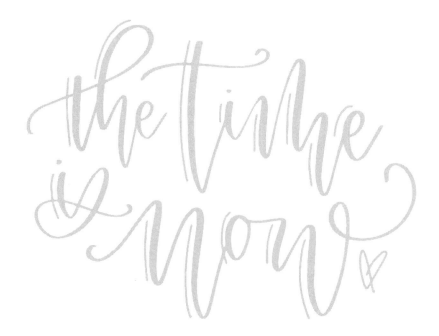

NOW TRY TO DUPLICATE MY DESIGN WITHOUT ANY GUIDES!

AND FINALLY, LETTER THE PHRASE IN YOUR OWN STYLE!